Layered and Stitched Pictures

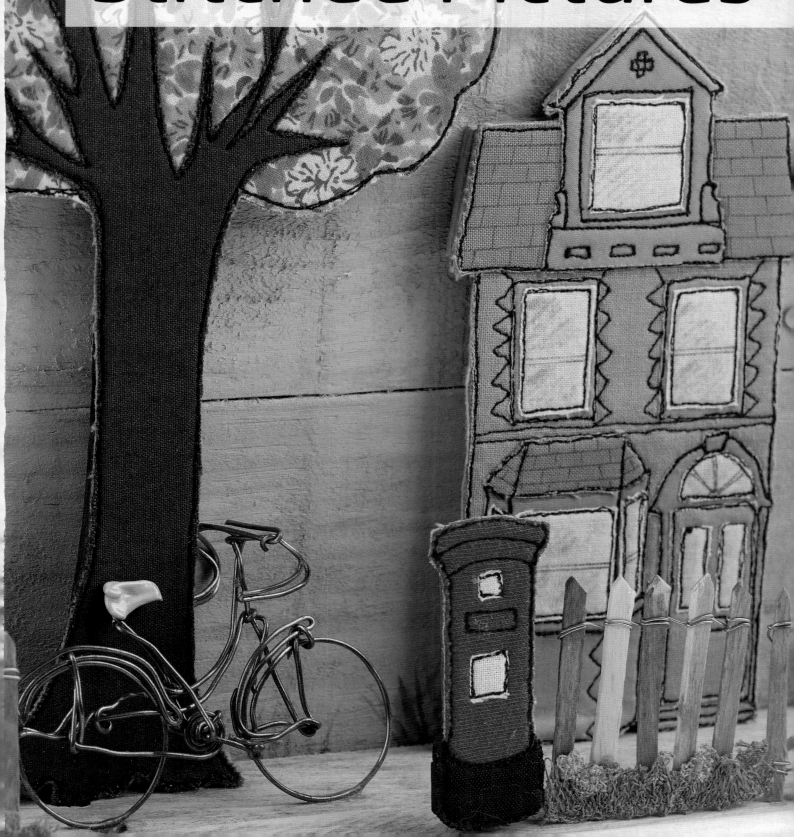

Layered and Stitched Pictures

Using free machine embroidery and appliqué to create textile art inspired by everyday life

Katie Essam

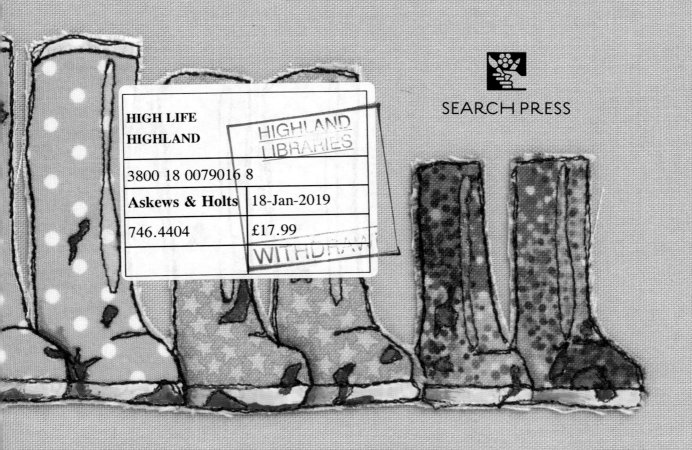

SEARCH PRESS

First published in Great Britain 2018

Search Press Limited,
Wellwood, North Farm Road,
Tunbridge Wells, Kent TN2 3DR

Text copyright © Katie Essam 2018

Photographs by Paul Bricknell at Search Press Studios, except for the cover, by Rachel Bingham of Fern Photo.

Photographs and design copyright © Search Press Ltd 2018

ISBN: 978-1-78221-513-4

The Publishers and author can accept no responsibility for any consequences arising from the information, advice or instructions given in this publication.

Readers are permitted to reproduce any of the items/patterns in this book for their personal use, or for the purposes of selling for charity, free of charge and without the prior permission of the Publishers. Any use of the items/patterns for commercial purposes is not permitted without the prior permission of the Publishers.

Suppliers

For details of suppliers, please visit the Search Press website: www.searchpress.com.

Publisher's note

All the step-by-step photographs in this book feature the author, Katie Essam. No models have been used.

Printed in China through Asia Pacific Offset

DEDICATION

To all those who can't help but make – let your creativity flow and imagination flourish.

ACKNOWLEDGEMENTS

Thank you to my husband for all your support, putting up with my creative 'mess' and for coming along on this ride with me. Thank you to my parents for your constant encouragement and nurturing my creativity. Thank you to Edd for all your book-writing wisdom and advice, to Paul for your brilliant photographs and to everyone else at Search Press who has had a hand in making this book become a reality.

Cover:

Bike Ride in Paris

Page 1:

Suburban Life

This is a detail from a larger, three-dimensional, mixed media piece which can be seen in full below. The little fence is made from wire and wooden coffee stirrers; a fun addition to the fabric houses that form the main part of the piece. The full textile art piece can be seen below.

Page 3:

Family of Five Wellies

A quirky take on a portrait, the wellington boots of each family member will be reminiscent of muddy walks on a Sunday afternoon all together.

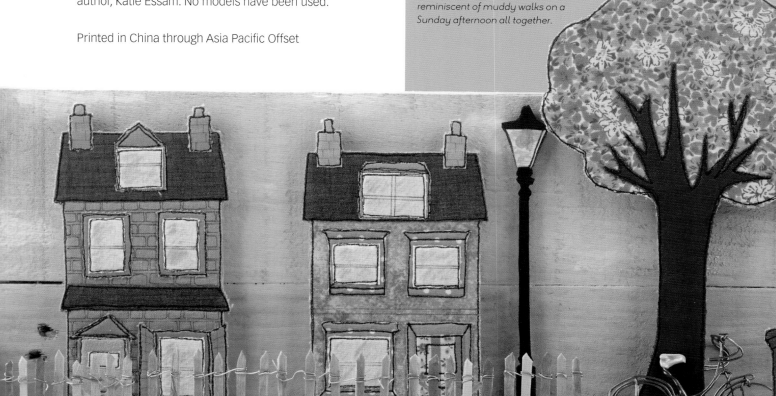

Contents

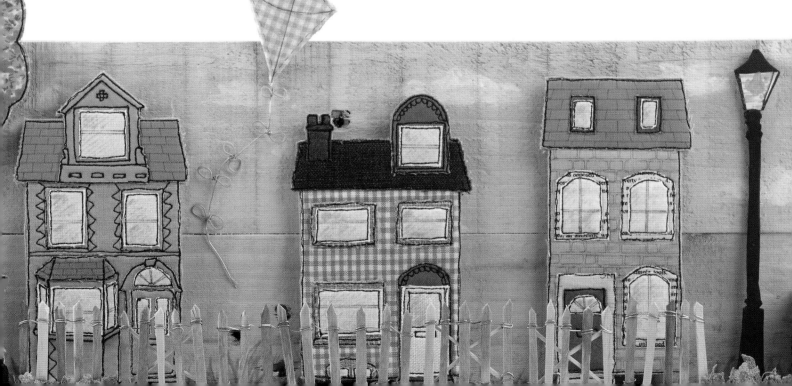

Introduction

Craft and creativity are simply amazing – it's no wonder so many of us are huge fans. Not only is crafting massively enjoyable, but it helps to get you thinking creatively, outside the box. It reduces stress and anxiety while increasing happiness and even improves your health. Crafting may even help protect the brain from ageing – it's a creative miracle!

I have always had the urge to make and create. As a young child I painted and drew whenever I could; baked and decorated cakes; and made anything and everything out of cardboard boxes. My passion for creating has only increased over the years. I have experimented and had the privilege to work with many different types of media, from textiles – including crochet, tatting, embroidery, and needle felting – to ceramics and glass; and to jewellery design, which included silversmithing, enamelling, resin and plastics. I have also worked with wood, using it for everything from jewellery to wall art.

After graduating with a BA Hons degree in Contemporary Applied Art from the University of Hertfordshire, I knew I didn't want to stop there; so I started my own business, designing, making and selling my creations, and it has all blossomed from there.

I have a particular love for combining different media; exploring how they work together, allowing their individual strengths to show and how they lend themselves uniquely to the expression of the subject. However, it has been textiles – especially freehand machine embroidery – that has truly captured my passion and attention. I didn't truly discover this until I had left university, which has allowed me, through experimentation and trial and error, to teach myself and come up with a unique way of working that suited me. This self-discovery has enabled me to produce lifelike textile artworks and unite it with my love of combining my media.

I get a kick out of challenging myself in my art, creating new, more intricate, more three-dimensional, more textured and more lifelike pieces. Similarly, I enjoy learning new skills to add to my repertoire: it helps to me keep inspired and intrigued as an artist. However, one of the most rewarding parts of my craft is being able to teach others the creative skills I have learned and honed, allowing them to take part in all the joy that making textile art can bring.

This book, therefore, is about you and your artistic journey. It is a guide to aid you in releasing the creativity that is inside you.

Please feel free to make the skills and the artworks that you produce your own. By all means use mine as a starting point, but try putting your own twist and self-expression in them as you get more confident. The projects are here to get you started and give you some inspiration – after that, the world is your oyster!

Try experimenting with the different media and techniques shown; find your own artistic voice and style. My aim is that you enjoy this book and making all the projects. I sincerely hope that, wherever you are on your creative path, it helps to takes you to a new and more exciting – and enjoyable – artistic level.

A selection of my finished pieces, including Five Chickens, Spring Wellies, Sleeping Fox, Jimmy the Cat and Chickens' Feeding Time. The way you choose to arrange or display your finished pieces can add another dimension to your textile artwork – the birds here seem quite alert to the sleeping cat and fox!

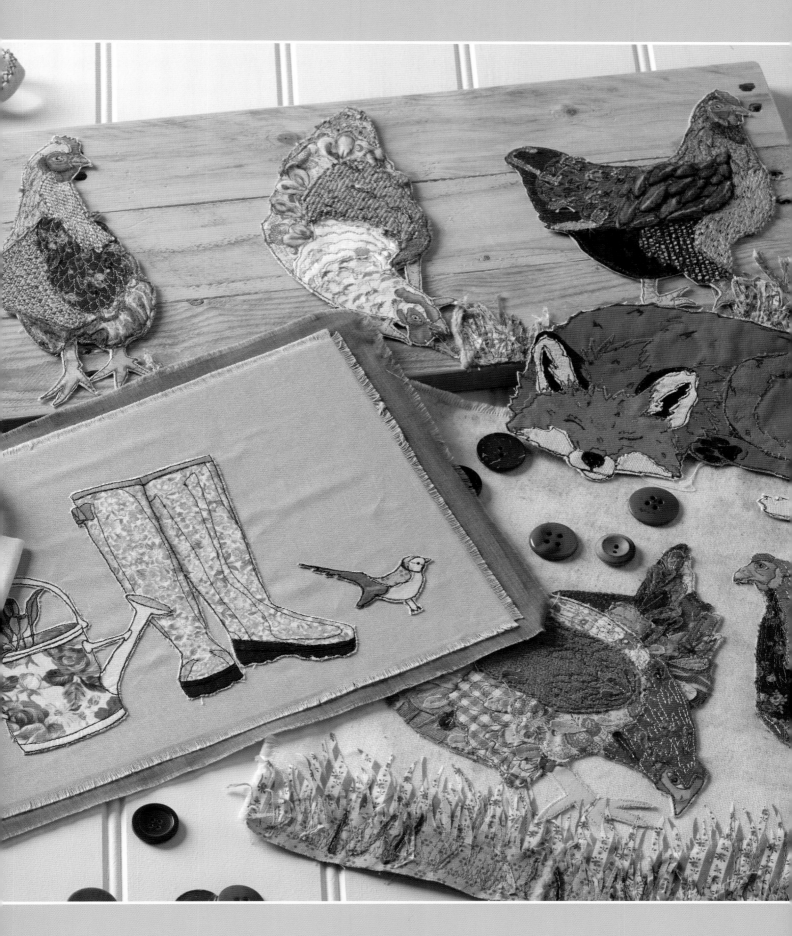

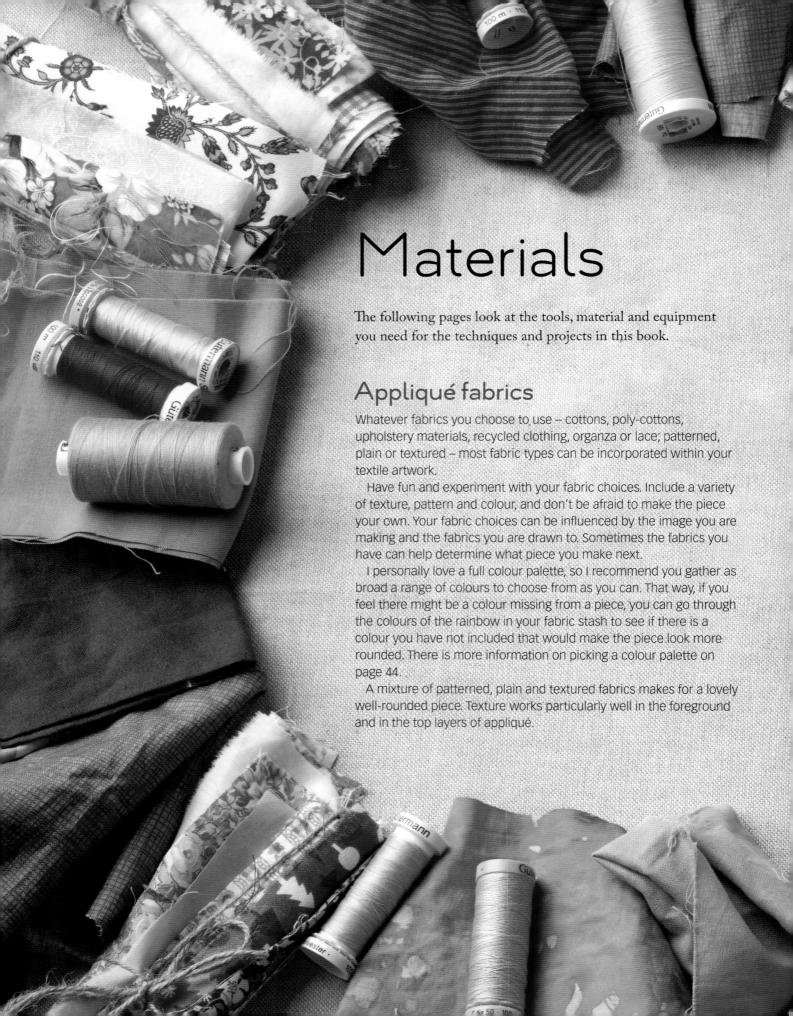

Materials

The following pages look at the tools, material and equipment you need for the techniques and projects in this book.

Appliqué fabrics

Whatever fabrics you choose to use – cottons, poly-cottons, upholstery materials, recycled clothing, organza or lace; patterned, plain or textured – most fabric types can be incorporated within your textile artwork.

Have fun and experiment with your fabric choices. Include a variety of texture, pattern and colour, and don't be afraid to make the piece your own. Your fabric choices can be influenced by the image you are making and the fabrics you are drawn to. Sometimes the fabrics you have can help determine what piece you make next.

I personally love a full colour palette, so I recommend you gather as broad a range of colours to choose from as you can. That way, if you feel there might be a colour missing from a piece, you can go through the colours of the rainbow in your fabric stash to see if there is a colour you have not included that would make the piece look more rounded. There is more information on picking a colour palette on page 44.

A mixture of patterned, plain and textured fabrics makes for a lovely well-rounded piece. Texture works particularly well in the foreground and in the top layers of appliqué.

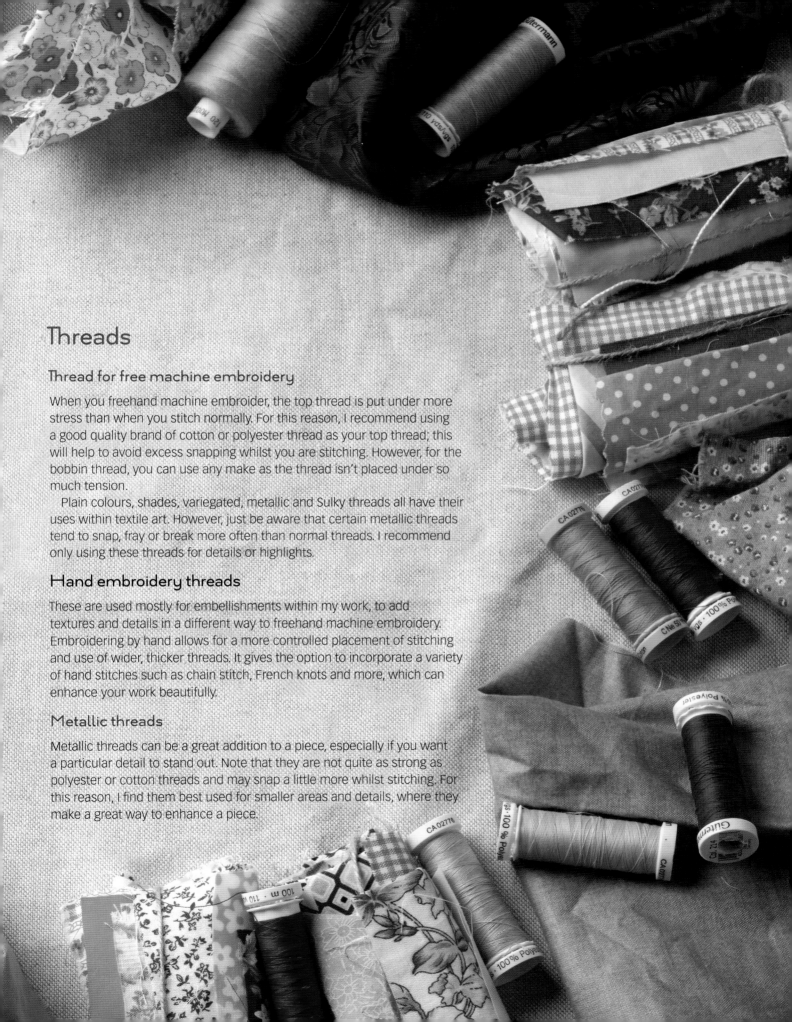

Threads

Thread for free machine embroidery

When you freehand machine embroider, the top thread is put under more stress than when you stitch normally. For this reason, I recommend using a good quality brand of cotton or polyester thread as your top thread; this will help to avoid excess snapping whilst you are stitching. However, for the bobbin thread, you can use any make as the thread isn't placed under so much tension.

Plain colours, shades, variegated, metallic and Sulky threads all have their uses within textile art. However, just be aware that certain metallic threads tend to snap, fray or break more often than normal threads. I recommend only using these threads for details or highlights.

Hand embroidery threads

These are used mostly for embellishments within my work, to add textures and details in a different way to freehand machine embroidery. Embroidering by hand allows for a more controlled placement of stitching and use of wider, thicker threads. It gives the option to incorporate a variety of hand stitches such as chain stitch, French knots and more, which can enhance your work beautifully.

Metallic threads

Metallic threads can be a great addition to a piece, especially if you want a particular detail to stand out. Note that they are not quite as strong as polyester or cotton threads and may snap a little more whilst stitching. For this reason, I find them best used for smaller areas and details, where they make a great way to enhance a piece.

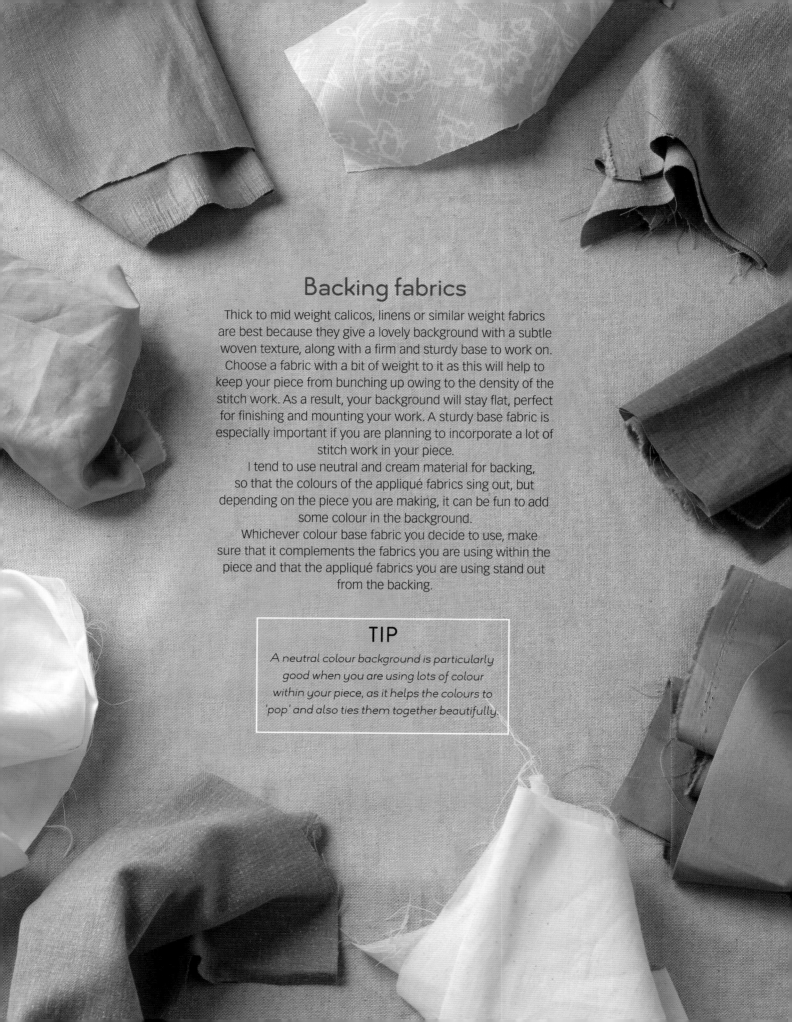

Backing fabrics

Thick to mid weight calicos, linens or similar weight fabrics are best because they give a lovely background with a subtle woven texture, along with a firm and sturdy base to work on. Choose a fabric with a bit of weight to it as this will help to keep your piece from bunching up owing to the density of the stitch work. As a result, your background will stay flat, perfect for finishing and mounting your work. A sturdy base fabric is especially important if you are planning to incorporate a lot of stitch work in your piece.

I tend to use neutral and cream material for backing, so that the colours of the appliqué fabrics sing out, but depending on the piece you are making, it can be fun to add some colour in the background.

Whichever colour base fabric you decide to use, make sure that it complements the fabrics you are using within the piece and that the appliqué fabrics you are using stand out from the backing.

TIP

A neutral colour background is particularly good when you are using lots of colour within your piece, as it helps the colours to 'pop' and also ties them together beautifully.

Interfacing, fusible webbing and pattern paper

Heat-fusible webbing There are many double-sided fabric adhesives out there, which are used by laying the adhesive on top of the back of your chosen fabric, and ironing it in place. The heat melts the glue webbing, which secures it to your fabric. When the fabric is then cut to the correct size and shape, the backing paper can be peeled away, and the appliqué piece placed down onto another piece of fabric and then ironed on in position. I tend to use Bondaweb 329 or Wonder Under made by Vliesofix, as these are widely available to purchase, and can be bought either by the metre (yard) or by the roll, depending how much you might use.

Pattern paper Any brand of this thin paper will do. I use one made by Burda. Pattern paper allows you to transfer the design accurately into stitch. With the paper you can draw guidelines to show where to embroider, which enables you to achieve perfect positioning of details. It also shows the precise and correct placement for all the appliqué pieces.

 If the paper has one shiny and one matt side, it is best to work on the matt side, as the pen can flow more freely.

Interfacing Stabilizer Vilene. I generally use Vilene H250/305, a medium to firm weight, iron-on interfacing; but the are many alternative makes, varieties, weights and types that will work. Find one that suits your way of working.

 Interfacing is ironed, with steam, onto the back side of the base fabric. It allows freehand machine embroidery to be done without an embroidery hoop or layers of thick fabrics. The interfacing stabilizes the base fabric, allowing smooth stitching without the fabric puckering. It also keeps the piece flat, without unwanted wrinkles when mounting and finishing your work.

TIP

If the ballpoint pen isn't working particularly well on pattern paper, scribble on a sheet of normal cartridge paper to get it flowing again.

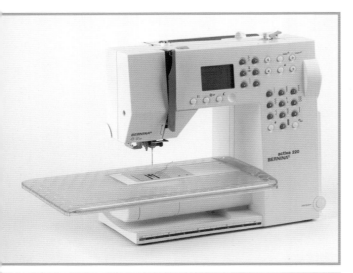

Sewing machine

You can use almost any machine for the free machine embroidery technique. You will need to be able to change the foot and drop or cover your feed dogs (the teeth that come up underneath the foot to pull the fabric through the machine while sewing).

Needles Normal-sized machine needles, 80–90 gauge, are fine for this type of embroidery unless you are stitching a piece with thick layers of fabric; then it is good to change to a thicker, more substantial needle to avoid it breaking.

Bobbins Make sure you have the correct bobbin type for your machine, as this can really make a difference to your sewing experience. Avoid using different weight threads on the top and in the bobbin, as this can play havoc with your stitched lines.

Embroidery foot In addition to your sewing machine, you will need a special embroidery foot to machine embroider. These are variously known as quilting, free-motion or darning feet. Whatever the name, it will have a circle, oval or U-shape at the bottom.

Embroidery feet can be purchased in haberdashery shops or online. If buying on-line make sure to add your machine make and model into your search as the feet aren't universal, although some feet may work for a number of different machines.

The sewing machine at the top is a standard model, but is perfectly suitable for the techniques in this book. The lower machine is my personal preference, owing to its larger working area, but you can add an embroidery table to many machines to achieve the same effect – as shown in the top image.

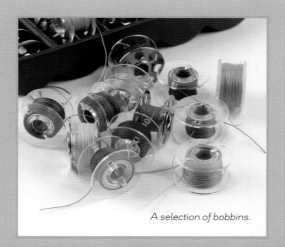

A selection of bobbins.

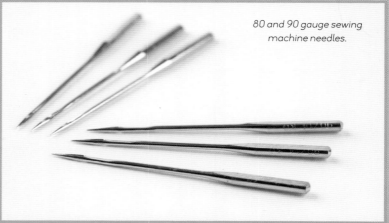

80 and 90 gauge sewing machine needles.

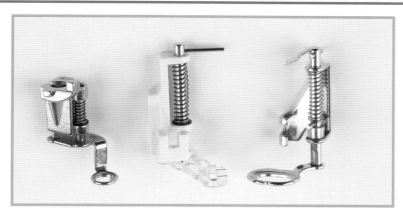

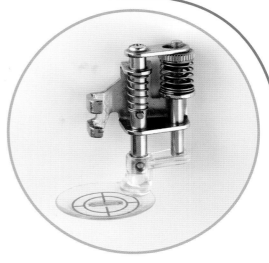

Embroidery feet come in different designs, but all work in a similar way. You can use a foot with an open toe (a C- or U-shaped foot with an open space at the front) or closed toe (a circular or oval foot, with the viewing area in the centre of the foot). Closed-toe feet, as shown above, are best to use when stitching in added textures to your work.

The foot on my preferred Janome machine is a specialist quilting foot. The large clear area is a great aid to visibility of the stitching as you work, with a handy target. It also works well when stitching in textures or fibres, allowing them to be trapped more securely between the foot and fabric when stitching.

Make sure to set up your machine somewhere comfortable, where you can concentrate on your sewing. Keep your tools and materials close to hand.

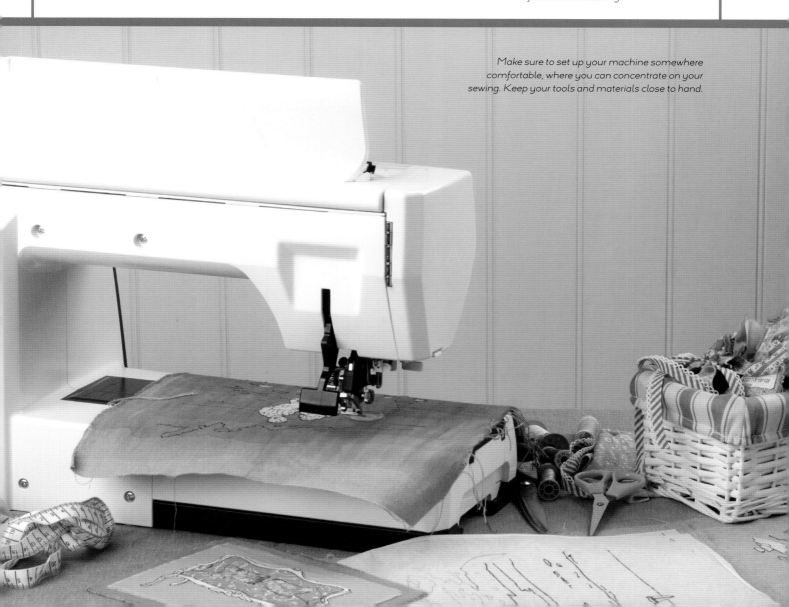

Other materials

In addition to the tools and equipment on the previous pages, you will need a few less glamorous, but no less important, materials.

Black ballpoint pen These are used for drawing out the patterns and tracing templates. I recommend using a pen rather than a pencil as the line is darker, clearer, and easier to see.

Ruler While not strictly essential, it is useful to have a ruler to check sizes. You can use a tape measure instead if you prefer.

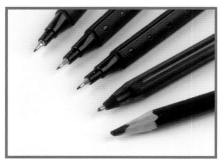

Fineliner and pencil Use these to add in any shading or details that are simply too fiddly to stitch or too small to paint. They are also useful for sketching out your ideas and plans.

Lint roller This sticky roller is the perfect tool to clear up all those loose threads and peeled-off pieces of pattern paper.

Tweezers Use these to remove any stubborn small bits of pattern paper left between your stitched lines after removing it. Scrape the ends over the stitch work to tease out the paper.

Fabric scissors A pair of large fabric scissors and a pair of small sharp ones will greatly aid your making process. You will find the smaller scissors very useful for detailed appliqué pieces.

Paper scissors Keep a small sharp pair of scissors specifically for cutting detailed templates from paper.

Iron and ironing board These are essential kit, especially when using heat-fusible webbing. Ironing boards are also a great height to work at when standing.

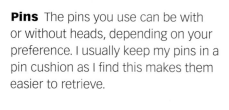

Pins The pins you use can be with or without heads, depending on your preference. I usually keep my pins in a pin cushion as I find this makes them easier to retrieve.

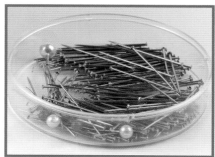

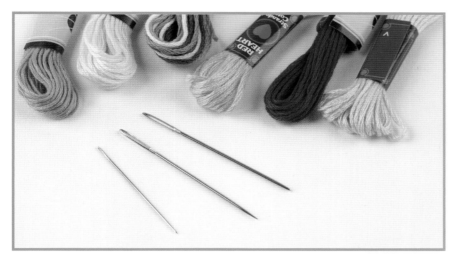

Needles and threads for hand sewing Sewing needles are used for those beautiful hand-stitched details. The size you need will depend on the threads you use. Including thicker silk threads and hand stitching is a great way to add texture and intrigue to your work. Experiment and have fun incorporating this technique.

Paints, paintbrushes and palette When adding in detail, highlights, shadow and colour, paint is a particularly good way to add depth, perspective and make a piece look more lifelike. Painting allows you to achieve effects and small details that you wouldn't be able to achieve with fabric alone.

I use both acrylic and watercolour paints, watering them down so that they can be brushed onto the fabric or paper smoothly. When you are painting in dark shadows, it is best to dilute the paint pigment even more, so as to avoid having an excessively dark or overpowering line of shadow.

In addition to the paint itself, you will need a pot to hold clean water, a few small brushes – I tend to use a small angled brush as this is versatile enough to paint almost anything I need – and a palette in which to prepare your mixes. A clean white plate works perfectly as a palette.

Use sheets of kitchen roll to clean your brushes and remove any extra water from your brush while painting.

Found items Small everyday items, such as book pages, sheet music, vintage haberdashery packets, lace, doilies, drift wood, wire, buttons, small ceramic fragments – almost anything can be incorporated into your art as a fun way of bringing the work to life. Found items add texture and intrigue.

TIP

Wool fibres; whether they are pieces of pre-spun wool/yarn ball, raw fibres, wool tops or natural wool roving are also great materials to use within your textile art to add texture.

Before you start

Advice and tips on working

As with everything in life, practice makes perfect. This book and the projects are here to teach you, and give you opportunity to practise your skills. I'm sure your artwork will be gorgeous but please don't expect to be producing masterpieces straight away, as it takes time to achieve very accurate control with free machine embroidery. However, my tips on page 22 will get you started on the right track.

Making a piece of textile art is huge fun, although the process can take a while, as there are many different steps involved. Each project uses quite a few different pieces of equipment and this can take up quite a bit of space.

I recommend splitting the projects up into sections and tackling one at a time, then clearing up the equipment you've just used before moving onto the next. For example, in one session you could work on preparing your templates, in the next do the first step of appliqué and cut out all of your pieces, in the third make your paper pattern and iron your appliqué pieces down in position, then in the next session move on to the freehand machine embroidery.

This is the way in which I tend to work; I find it reduces the amount of mess and stress and leads to a better use of time.

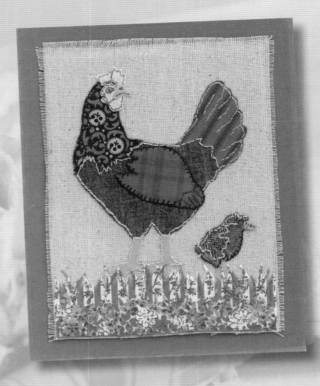

Enjoying yourself

Enjoy yourself! Art is about letting go, getting creative and self-expression. Allow yourself time and space to practise and experiment. See the projects as activities to help you acquire and develop your skills rather than pressuring yourself to produce a perfect piece straight off.

Feel free to have fun and play! As you get more confident, try different techniques; this will help you to learn – whether this is a better way to do something or simply how what to avoid next time!

PURE HAND STITCHING

The techniques of appliqué, templates and fabric layering taught in this book can also be combined with hand stitching rather than freehand machine embroidery, if you fancy a change or want to experiment with a different technique and finish to your artwork.

Sometimes a slow stitch can be very therapeutic and it will also give you a bolder stitched line. I use a back stitch to achieve a similar line of stitch to the machine embroidery , as shown in the piece above.

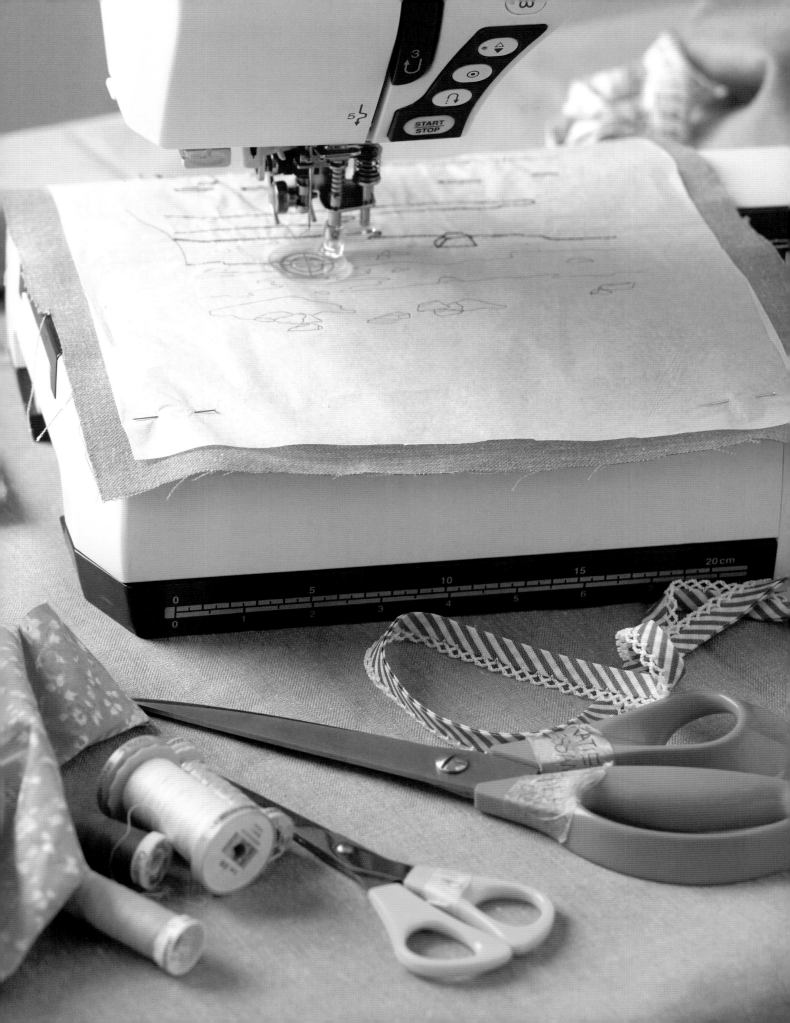

Setting up your machine

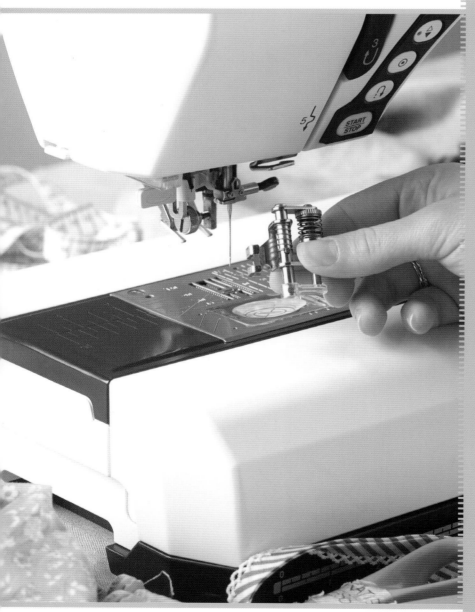

Free machine embroidery is simply drawing with thread. Whether you prefer to stitch quickly or slowly, it doesn't matter as long as it is comfortable for you and you feel in control. Find a speed of stitching that works for you, allowing you to achieve a nice even stitch size. When practising on your practice sampler (see pages 24–25), you will find your pace.

Attach the foot

To prepare your sewing machine to freehand machine embroider, you will need to remove the normal foot and replace it with your embroidery foot (see page 14). Some machines may come with an embroidery foot, so make sure you look through your spare feet before buying one.

Tension

In general, I find it best not to touch the tension. Leave it set at 'auto' or the default sewing tension for your machine, unless your manual states otherwise for free-machine embroidery.

Troubleshooting

If you are having any issues with your stitches, re-thread the bobbin and top thread and try turning the machine on and off again. If the problem persists, try filling up your bobbin, as sometimes a near-empty bobbin can cause the tension of the bobbin thread to be too loose.

Other checks

Check your manual to see whether there is anything specific that you need to do to your machine beforehand in order to prepare it for freehand machine embroidery.

If you have an older sewing machine, look for where the manual refers to darning.

Dropping your feed dogs

Feed dogs are the teeth that come up underneath the foot to pull the fabric through the machine while sewing and regulate your stitch length. For freehand machine embroidery, your feed dogs should be down, so they are not pulling your fabric, and you can control the direction of stitch and stitch length yourself.

Check your sewing machine manual to locate the switch or button that drops the teeth. If the feed dogs don't drop, certain machines have a cover or plate that goes over the top, so that the teeth don't affect your embroidery. If you don't have a plate, you can always use strips of masking tape to completely cover the teeth: just remember to make a small hole and thread your bobbin thread through before you start stitching.

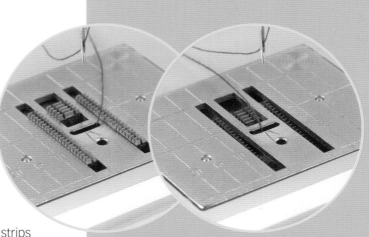

Feed dogs up (left) and feed dogs down (right).

Stitch length

As your feed dogs are down for this type of sewing, the machine will not determine your stitch length. As a result, there is no need to adjust the stitch length settings. With the exception of some digital sewing machine models (check your manual to see whether it tells you to place the stitch length at 0), the length of the stitching on your fabric is all down to you: how fast the needle is going up and down and how fast you are moving the fabric.

The stitch length is determined by your movement. If the needle is going up and down very quickly and you are moving the fabric slowly, your stitches will be tiny. If your needle is moving slowly and you are moving your fabric quite quickly, your stitches will be long. With this technique, you are aiming for a smaller stitch than when sewing normally; around 1mm in length.

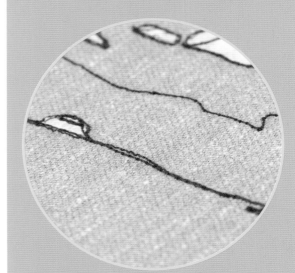

This example shows the small, even, but non-uniform stitching for which you are aiming.

Threading your bobbins

For your bobbin thread, I recommend using the same or a very similar colour thread to the one you have chosen for your top thread, because the bobbin thread will be visible at the front of your piece.

TIP

Make sure your top and bottom threads are the same thickness. This will help to ensure smooth stitching.

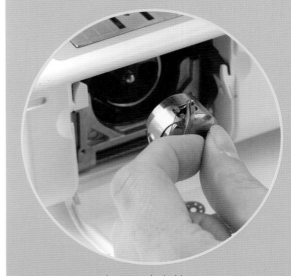

Inserting the bobbin.

Top free machine embroidery tips

The technique is called 'free' machine embroidery for a reason: the fabric is unconstrained and free to move. Unlike regular sewing, where the machine will draw the fabric through away from you, with free machine embroidery you can stitch from side to side, diagonally and forward.

Think pen

Before you get stitching, try out this quick exercise. Take a piece of paper; place it on a flat surface. Ask a friend to hold a ballpoint pen still, in one position, just above the surface of the paper, but close enough that the tip touches and can make a mark. With the other hand move the paper around to make the pen draw on the paper, as shown in the sequence to the right. This is the motion you will want to be using when freehand machine embroidering.

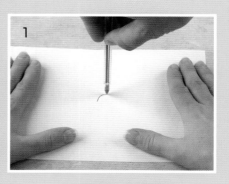

Keep control

When stitching your piece, try not to rotate your fabric around the needle as well as moving it from front to back or side to side. You will find the dual motion of the fabric can mean you lose that controlled line. In particular, avoid working backwards if at all possible, as it will mean that you can't see where the stitching is going.

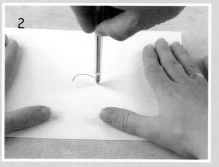

If you are finding it difficult to control your stitching and it feels as though you are fighting against the needle as you sew, try moving the needle up and down just a little faster; this should give you a better flow.

Rest your arms

Resting your forearms on the edge of the table in front of the machine can provide more stability and control. Don't rush yourself; you will get quicker and more accurate the more you practise.

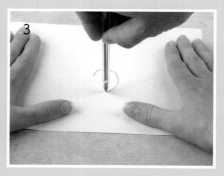

There is no need to stop and start when you reach the end of your line: continue sewing to the next part.

Stay steady

Don't 'walk' with your hands (picking them up, moving and replacing them on the fabric whilst still stitching); keep them in the same position until you stop.

Stop!

When you feel like you are losing control of your stitching or your hands are too far away from your needle, stop. Don't rush to get the end of your line. Lower your needle into the fabric where your last stitch ended using either your hand wheel or a button, re-position your hands and start again. The point at which you feel you are about to lose control is often when you make a mistake or stitch less accurately.

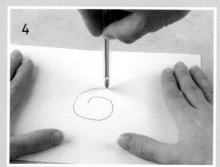

Re-thread

If your stitched line doesn't look right at the front or back, try re-threading your bobbin before anything else. If the problem persists, re-thread your top thread too. These tend to sort out most issues. As a last resort, try turning your machine off for about ten seconds, then on again.

Try stitching side to side as well as forward

Many people find this gives them a more accurate line, especially when going in a straight line.

Work twice

It is best to go over your lines twice. This gives a more defined line that helps cover up any slightly wonky lines, and gives a lovely 'handmade' stitched effect. It also lets the stitched line stand out more effectively on patterned appliqué fabrics.

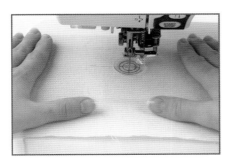

Hold the fabric steady and move it smoothly sideways to achieve an even line.

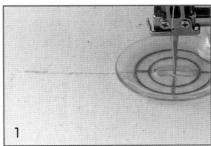

I worked from left to right for this single line of stitching, creating a smooth line.

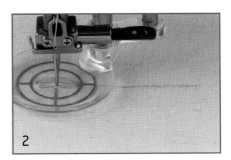

Working backwards over the line again adds depth and interest.

Lower the needle at the end of a line

Get into the habit of lowering the needle into the fabric when you stop stitching, before turning your fabric or repositioning your hands, as this will aid your stitching progress.

Some sewing machines have a button that allows the needle to finish stitching either in the up or down position: select the 'down' option and you won't have to remember to do the above.

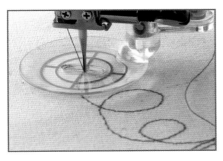

Whether working straight lines or curves, as here, develop the habit of lowering the needle at the end.

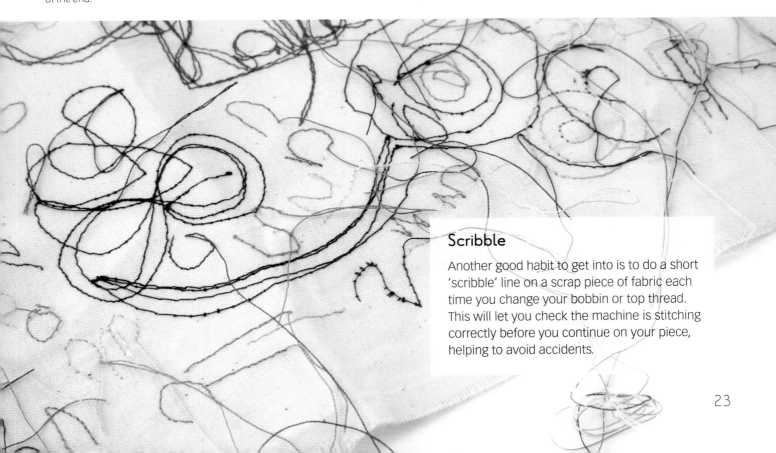

Scribble

Another good habit to get into is to do a short 'scribble' line on a scrap piece of fabric each time you change your bobbin or top thread. This will let you check the machine is stitching correctly before you continue on your piece, helping to avoid accidents.

Practice sampler

This is your practice piece for you to get the feel for freehand machine embroidery before you start work on the projects. You will need a piece of calico fabric, roughly A4 in size – that is, 21 x 30cm (8¼ x 11¾in) – and a slightly smaller piece of iron-on interfacing.

1 Make sure you have your machine embroidery foot on and that your feed dogs are dropped or covered.

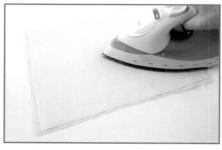

2 Secure the interfacing to the back of the calico piece with an iron (full heat and steam). The shiny side is the glue side, which goes onto the calico face down.

TIP

The interfacing will stabilize and support the fabric when stitching, ensuring that the fabric will not bunch as you stitch. The same effect can also be achieved using an embroidery hoop, but I have found that interfacing gives much more freedom while stitching as it doesn't restrict where you can stitch or get in the way, as a hoop can.

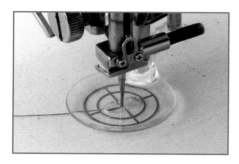

3 Place the material/calico into your sewing machine, under the foot with the interfacing facing down. Bring the foot down in the middle of the fabric, then slowly lower the needle into the fabric in preparation to start stitching.

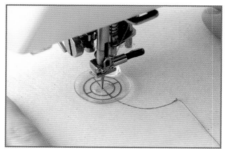

4 Start stitching a curve. Unlike normal sewing, you do not turn the fabric. Instead, keep it parallel with the front of the machine and move the whole piece of fabric.

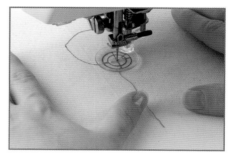

5 Keeping the fabric parallel to you, complete the circle.

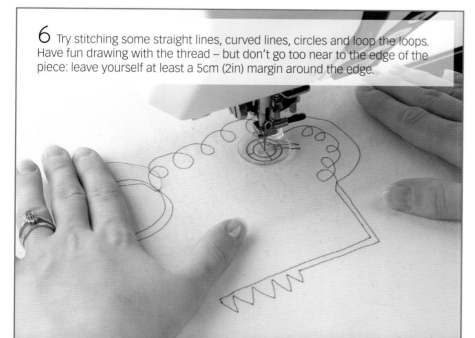

6 Try stitching some straight lines, curved lines, circles and loop the loops. Have fun drawing with the thread – but don't go too near to the edge of the piece: leave yourself at least a 5cm (2in) margin around the edge.

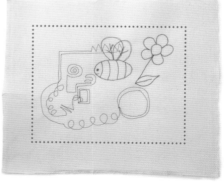

The nearer you get to the edge, the less control you will find you have as you have less material to hold onto. This picture of the finished sampler shows a dotted line 5cm (2in) in from the edge – don't work past this border. On a similar note, do not stitch on the fabric past the end of your interfacing.

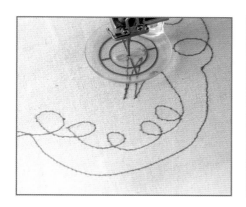 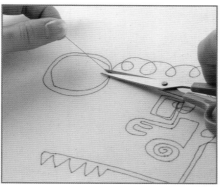 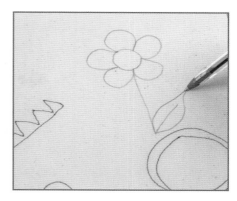

7 As you work, aim to keep your stitches around 1mm long. Imagine you are a toddler with a ballpoint pen – scribble, wiggle and flow freely.

8 Continue doodling until you feel you are starting to get the hang of the motion, pace and stitch length of freehand machine embroidery. Once finished, remove the fabric from the machine and trim any loose threads.

9 Next, use a ballpoint pen to draw yourself a very simple small design, with both straight and curved lines such as this flower, near the middle of your fabric. It doesn't matter if it's over lines you have already stitched.

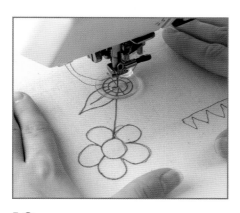

10 This activity is to help you achieve a more accurate stitch and teaches you to stitch on a line. Stitch on your drawn lines and go over each line twice as this gives your piece a more hand-stitched look and also helps to correct any 'wiggles' in your stitching from your first time around. Be aware that your aim and control won't be perfect. As with anything, your skill and accuracy will improve with practice.

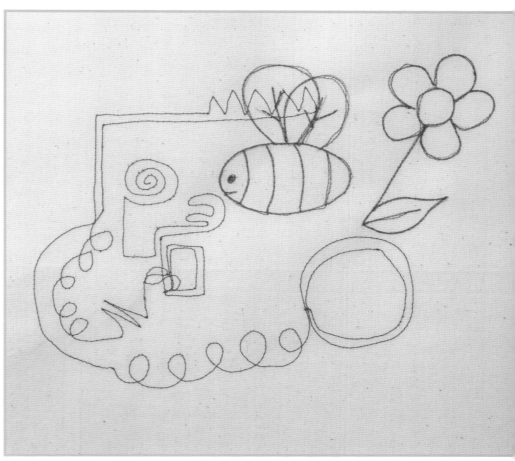

The finished sampler

If you wish to draw yourself another simple sketch for more practice, please do. At this point you will visibly see your improvement from exercise to exercise.

This is the start of your creative freehand machine embroidery journey. Keep going and practise, you will keep improving with time. It's such a great, fun and a creative way to use your sewing machine, breathing new life into it. However, I must warn you that it is a tad addictive!

Beach Scene

This design was inspired by a beach holiday in Wales. I made a simplified sketch from a photograph that I took there, aiming to keep just enough of the details and objects on the beach to show what had attracted me to the subject matter while removing excess information.

This project shows how simple but effective the combination of black stitch and pattern paper can be. This is a great place to start if you are new to freehand machine embroidery, or even new to this image transfer technique.

I mentioned on page 18 that it is a good idea to break your project down into more manageable sections. As you work through this project, you will see that I have done just this, separating the main stages out into distinct techniques so that I can explain a little about how to approach each stage. You don't have to stop at the end of each, of course – if you are enthused, you can carry on right from start to finish.

Using the rules of perspective, I have picked out more detail in the foreground and less in the background. The blue backing fabric was chosen to add a kick of colour to the piece: its blue hues add more of a 'seaside feel' to the artwork. This project should teach you that a piece or image doesn't need to be complex, multi-layered or technically difficult to give a stunning or striking effect.

YOU WILL NEED

Equipment:
Sewing machine, embroidery foot, needle, bobbin
Iron and ironing board
Black ballpoint pen
Fabric and paper scissors
Pins
Lint roller (optional)
Sticky tape
Tweezers

Materials:
Base fabric – at least 28 x 34cm (11 x 13¼in)
Pattern paper
Iron-on interfacing
Black thread

Opposite:
The finished piece

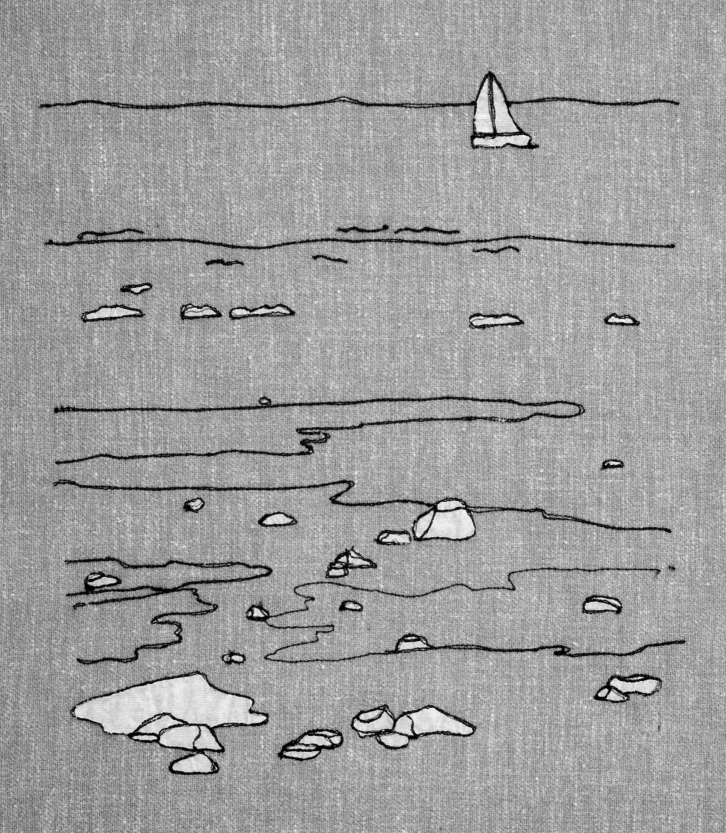

Design for *Beach Scene*

This design is provided at full size.

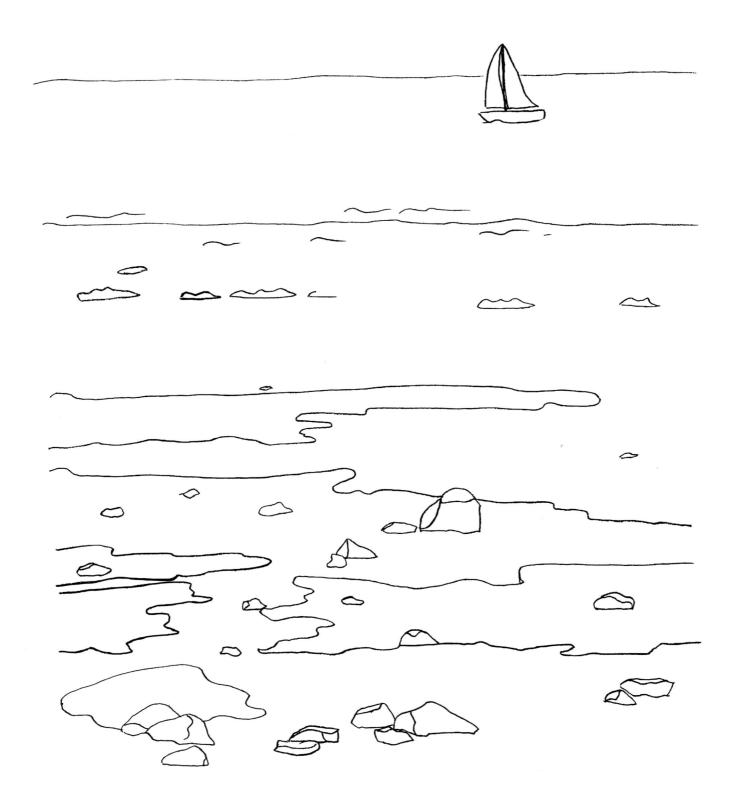

Transferring the design to pattern paper

Pattern paper is a great way to achieve a guideline for your stitching. It makes the design easy to transfer and trace through, which means your image and guidelines are as accurate as they can be, the right size and in the right place.

Most pattern paper has a matt side and a shiny side. Generally, you should draw on the matt side. Not only will the pen run more smoothly there, but if you need to leave areas of the pattern paper on the artwork, the matt side gives a more pleasing effect to the piece.

1 Cut the backing fabric to size, using the design opposite plus a 5cm (2in) margin on each side. Cut out a piece of iron-on interfacing that is 2cm (¾in) smaller on each side than the backing fabric.

2 Using full heat and steam, iron the shiny (glue) side of the interfacing to the back of the backing fabric.

3 Cut the pattern paper to slightly larger than the design, then use a black ballpoint pen to trace the design on to the pattern paper, leaving a margin of 4cm (1½in) or so around each edge.

TIP

Use a small piece of sticky tape to secure the pattern on the back side of the pattern paper to stop it moving as you draw.

4 Pin all four corners of the pattern paper onto the front side of the backing fabric. You are now ready to sew!

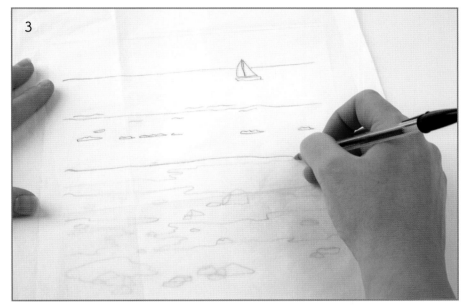

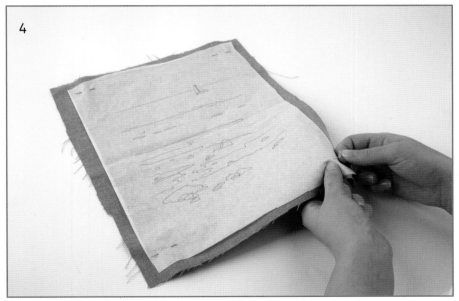

Free machine embroidery

Trimming the loose ends as you go along reduces the risk of getting tangled up as you work, but in pieces with lots of individual details, like the small waves and rocks in this piece, removing the piece and trimming the thread can be both fiddly and time-consuming if you stop and start in between each one. However, doing the trimming in between larger areas – background, midground and so forth – rather than with each detail, saves you time, and is a less stop–start way of working.

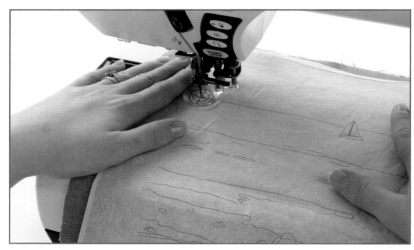

5 Using the hand wheel, lower the needle onto a line you wish to start stitching, through the pattern paper and fabric.

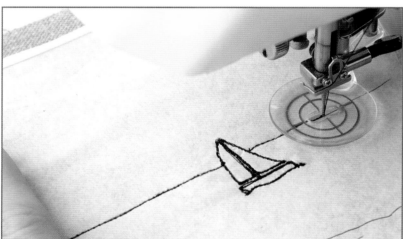

6 Smoothly move the backing fabric with the design through your machine, stitching steadily over each line twice. Try to find a route that allows you to work smoothly round the lines and shapes to minimize starting and stopping.

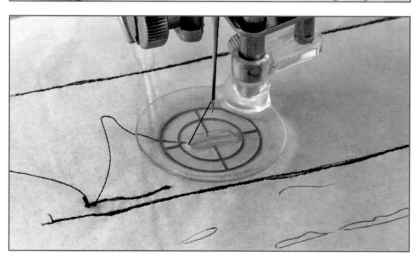

7 As mentioned above, there is no need to remove your piece from the machine between each rock or detail: as you finish the first individual wave, lift your needle out of the piece as far as it will go.

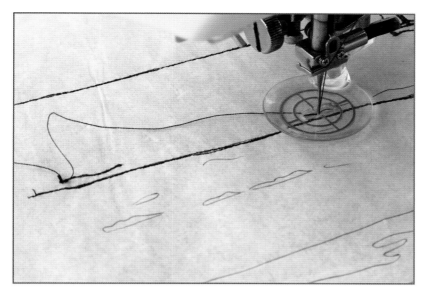

8 Move the fabric and lower the needle back into the next place you wish to stitch (another small wave, in this example) using the hand wheel. You can snip the small thread left in between when you have finished stitching.

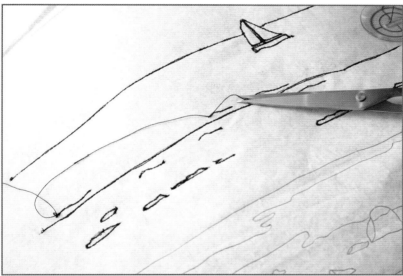

9 When your stitching in an area is complete, cut all hanging threads in the area with a pair of sharp scissors.

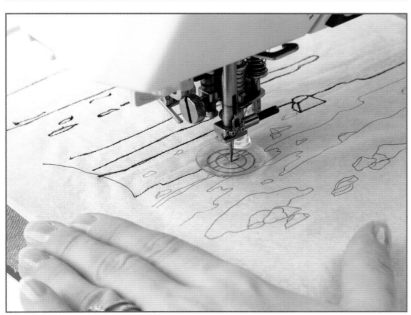

10 Once the area is complete, carry on stitching the remainder of the design in the same way, breaking it down into larger 'chunks': the midground and foreshore, for example.

Removing pattern paper

Pattern paper is usually removed completely, but leaving it within enclosed areas of stitching, like the rocks here, gives a fantastic effect. Since the paper tears easily, you need to work carefully when removing it.

11 Remove the pins.

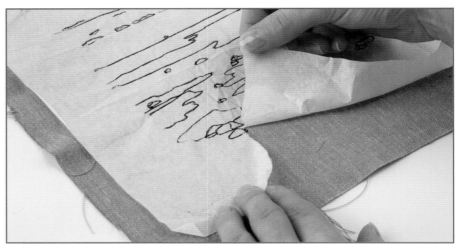

12 Working from the edge of the paper into your design towards a line of stitching, tear the paper in a controlled way.

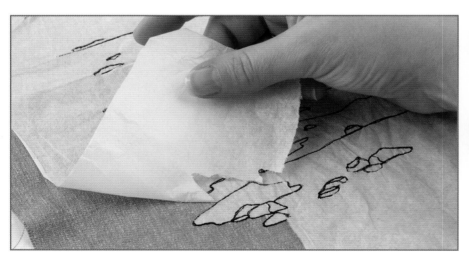

13 Rip the pattern paper away from the line of stitching – working at a 45-degree angle from the stitching will give a clean tear.

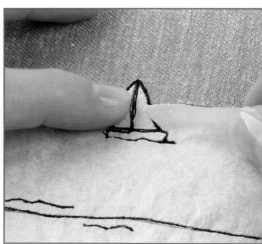

14 Work round the rest of the design. Try to leave the paper within the small boat and rock shapes – put your finger on them to hold them in place while you tear away the surrounding paper.

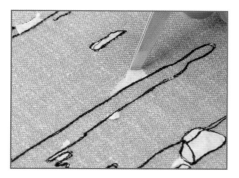 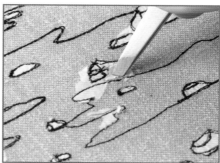

TIP

You can use a stitch unpicker instead of the tweezers to help remove small pieces of paper.

15 To remove any small bits of paper left between your stitched lines, use a pair of tweezers to help wiggle the piece out of the stitching.

16 You can use the side of the tweezer ends to gently scrape the surface to remove stubborn pieces of paper.

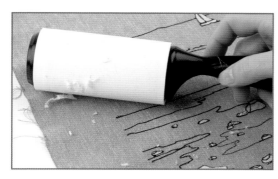

17 Use a lint roller to remove the loose bits of paper selectively – be careful not to accidentally tear off the paper from the rocks and boat.

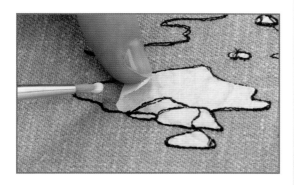

TIP

If you do accidentally tear the paper from a rock or the boat while you are working, you can use fabric glue to repair the damage.

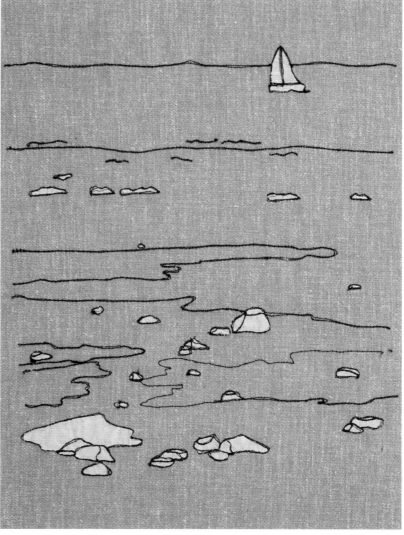

A larger version of the finished piece can be seen on page 27.

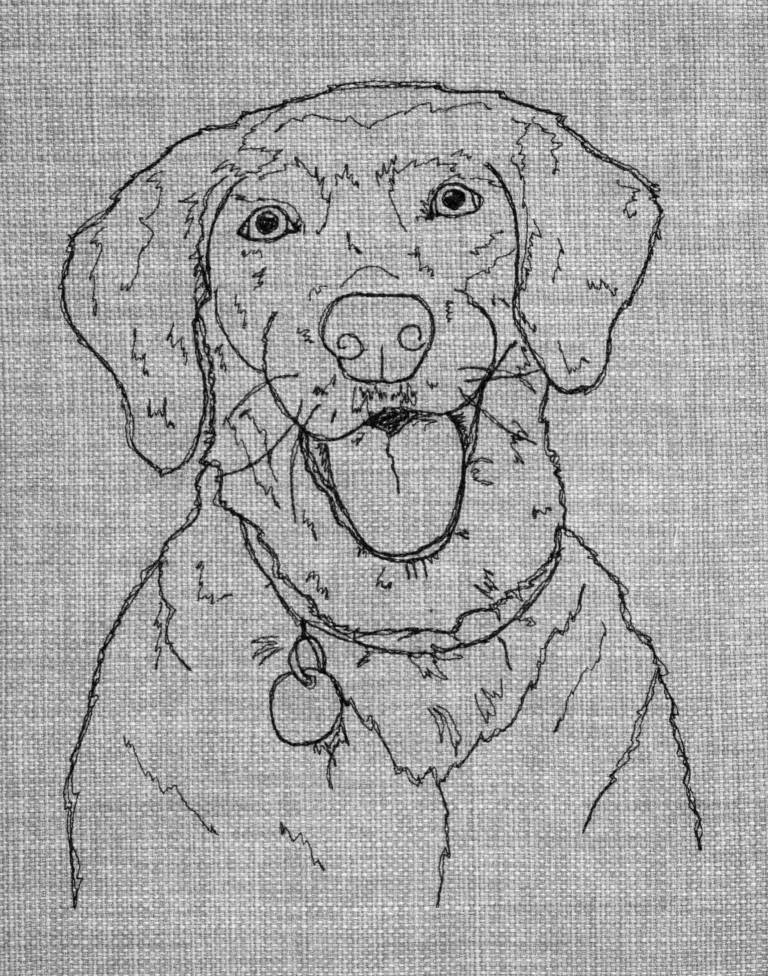

Feebi

This piece is inspired by a picture of my Labrador, Feebi, and demonstrates the way freehand machine embroidery can be used to interpret texture beautifully.

It is a simple line portrait that incorporates lots of zigzag stitched lines to show the direction and texture of the fur. This approach helps to create the illusion of the dog's fluffy coat. The lovely background fabric is quite heavily textured, and has a loose weave. This works to complement the simple stitched-line piece.

While the technique is identical to that used for the beach scene project on the previous pages, here all the pattern paper has been removed, and so I have strengthened the stitching by using thread shading and overworking techniques to give the image a little more strength and boldness.

Sometimes I appreciate a more simple, stripped-back approach to working a piece, and choose to avoid appliqué, instead letting the stitch work do all the talking.

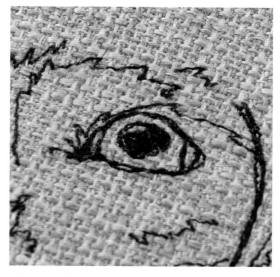

Fleck in the eye

Including either a white fleck or a gap in some solid stitching in the eye is very important when making a portrait, whether of an animal or a person. It is this small reflection in the eye that gives life to the subject. Because I was using just black thread in this piece, I have chosen to leave a gap.

Thread shading

Working the thread over and over to fill the spaces in the darkest areas of the image is called thread shading. This is a great way to add depth and definition to a piece.

Overworking the line

With this piece, I've chosen to stitch the outline three times, rather than twice as I usually would. As well as making the dog look even more furry, the extra stitching makes the piece stand out more, which is important when working on heavily textured fabric like the background material here.

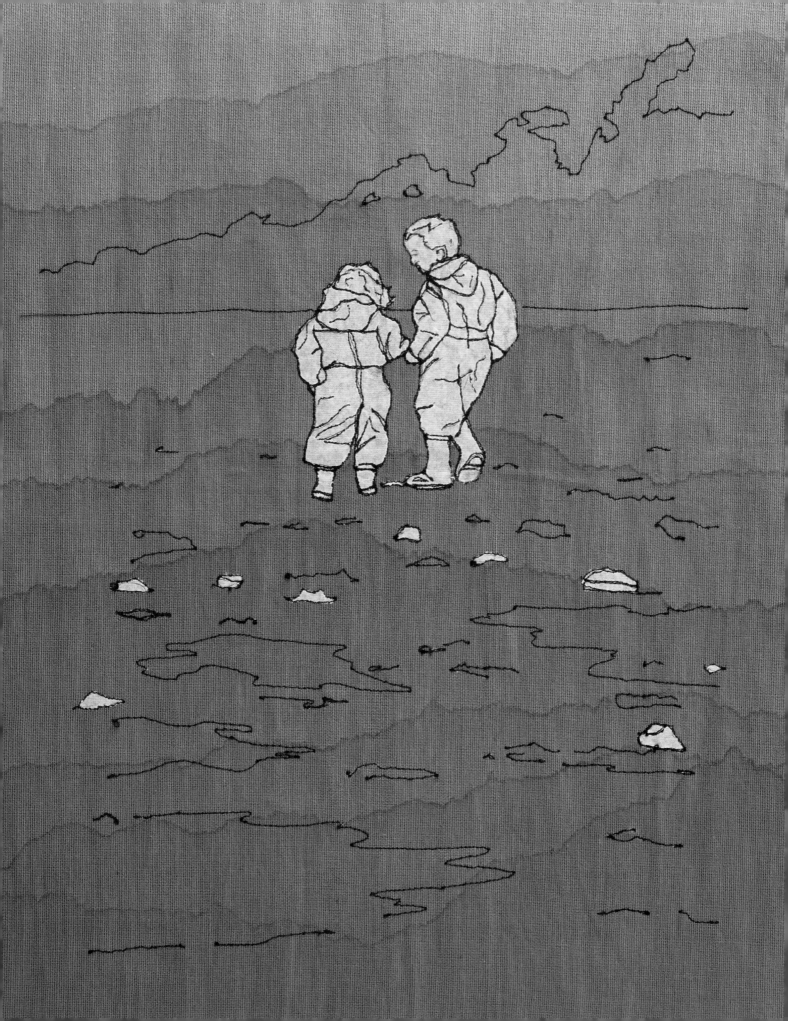

Winter Walk on the Beach

This variation on the project focuses on a pair of figures rather than a boat, giving a more intimate feeling. When planning this textile artwork, I used the 'rule of thirds', which we will look at in more detail on page 42.

Tea staining

The linen background was dyed in layers using tea; simply soaking the fabric in cold strong tea before laying it flat and allowing it to dry. You or your children might have tried the technique at school to 'age' a letter or treasure map.

Make sure that the fabric is completely dry from the previous dye before starting the next one. A cool oven, at about 100ºC (212ºF) can be used for a faster drying time.

To create the tide marks on my linen for that extra 'beachy' feeling, I simply repeated the technique a number of times, soaking less and less of the fabric with tea. The repeated layers help to strengthen the tone.

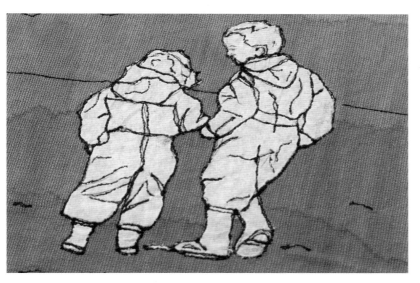

Figures

These simple figures on the beach include stitched lines where their clothes fold or bunch. As in the main project, pattern paper was left under the figures to make them stand out against the background. You might try selectively removing areas of paper from your figures, but I kept these important focal points intact for maximum impact.

Rocks

As in the previous project, I've left some pattern paper under a few of the rocks for a few extra details and to help lead the eye to the figures.

Finding ideas and inspiration

I often find my inspiration simply pops up in my everyday life. A walk or bike ride in the countryside can spark off a chain of ideas that culminates in a design. In the same way, ideas can pop up from childhood memories, or simply from seeing a particularly image that resonates with you for some reason.

Draw inspiration from all around you. Look for shapes, subjects, and colours. Inspiration can even come from the materials you use – looking through your collection of fabrics and threads might lead to you seeing a pattern or texture that results in a new idea for a project.

With the digital age in full swing, inspiration is always at your fingertips. Use your computer or smartphone to browse Facebook, Instagram, Pinterest or some of the many other platforms in order to pick up ideas and inspiration.

At root, there are multiple ways to capture ideas – choose a way that suits you and what you enjoy doing.

Journalling

Journalling is simply keeping a record of your inspiration in notes or pictorial form. It could be in a sketchbook or scrapbook, or online somewhere like Pinterest: keep the ideas flowing and record them when inspiration strikes. Start by collecting imagery that inspires you. Photographs, sketches, pictures, images from the internet, greetings cards and other people's artwork are all valid sources; just be careful to make the piece your own, rather than copying directly. Often, multiple sources can influence one piece; this is a great way to make sure you are making new original art, true to your creativity.

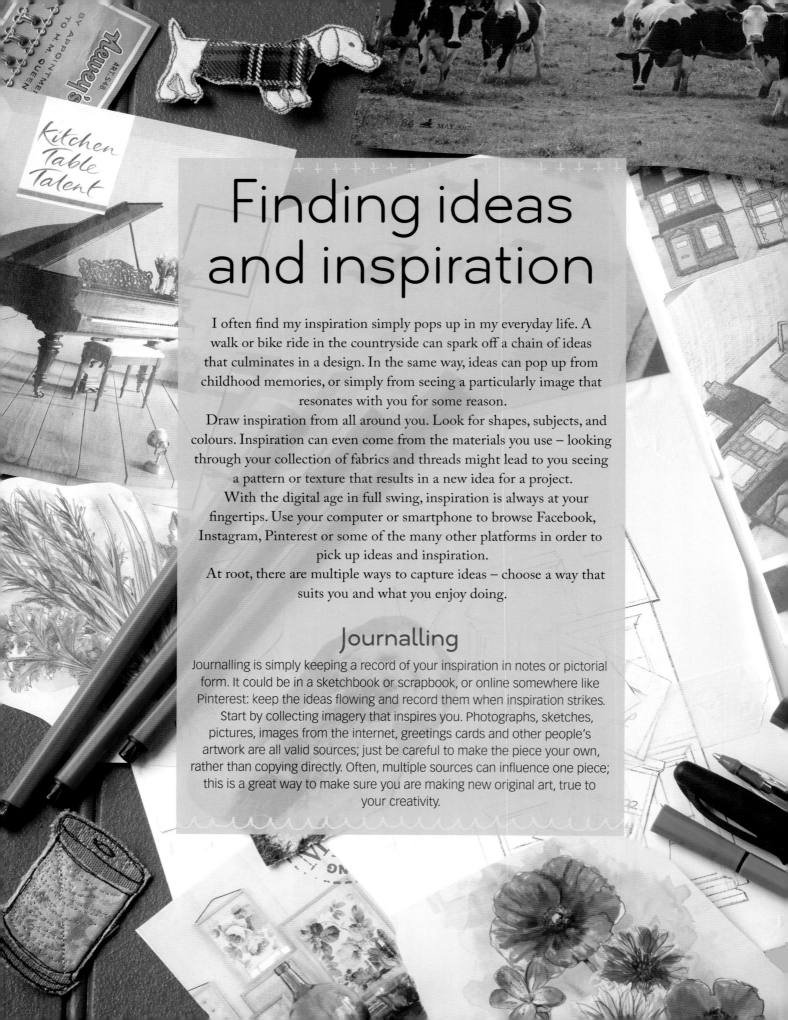

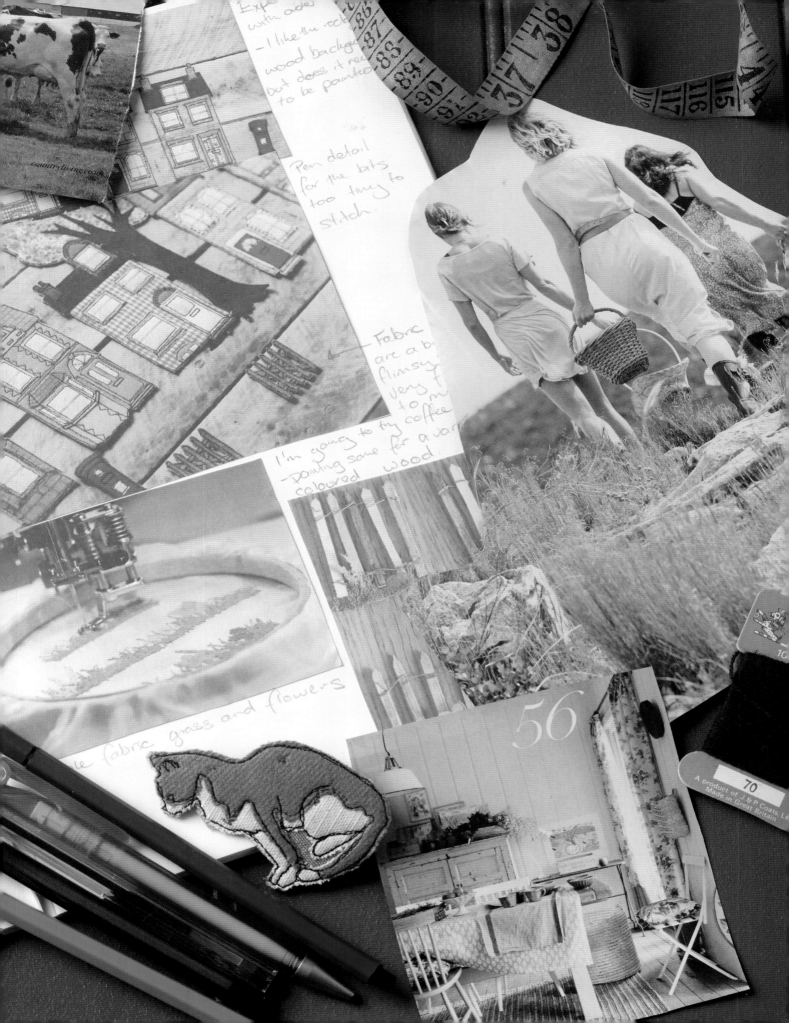

Exp...
with ad...
- I like the recl...
wood backg...
but does it re...
to be painted?

Pen detail
for the bits
too tiny to
stitch.

Fabric
are a b...
flimsy
very f...
to m...
coffee

I'm going to try
- Painting some
coloured wood.
for a var...

le fabric grass and flowers

countryliving.co.uk

56

A product of J & P Coats, L...
Made in Great Britain
70

Planning

Once you have your subject matter, you need to make a plan to work out how to move from your initial idea to the piece itself. I recommend working from a single image that you are really drawn to, whether this is a photograph or a drawing. As you get more confident in creating your own designs and images you can try combining images and ideas from multiple sources to create your own truly unique image.

As you work through your plan, you may find that you need to adjust your idea as you work. Some of the challenges are practical – if you cannot find enough of a certain fabric, for example, you will have to choose another. Others are more theoretical – ensuring you create an effective composition, or pick a suitable colour scheme. The following pages explore ways to give you a head-start on developing your own ideas into practical plans.

From idea to reality

Each person will work differently to get from their initial inspiration to a formed design. A good starting point is to read around or research your idea to get an image forming in your mind. However you like to be inspired and collect ideas – whether you sketch, photograph, cut out images from magazines or find images online – all can work. Experiment to find what works for you. Draw from multiple sources until you narrow down exactly what it is you would like to make.

You may wish to work from a single strong image – a favourite photograph or sketch, for example. In these cases, simplifying your image can help to give a stronger result. Remove clutter from the image by isolating certain points of interest within the image and ignoring others. The *Beach Scene* project on page 26 is a good example of how a complex image can be simplified for a more effective piece.

Creating a line drawing from a photograph or sketch is a really good to place to start. Aim to simplify the picture in front of you, so that it is not over-complex but still shows the subject matter. The technique is shown in the project on pages 108–115. A line drawing also allows a freedom of colour palette and a clean image to work from.

Collating a number of different items and inspiration sources into one piece can be another great way to make your piece as unique as you. For example, a lady attending one of my workshops loved Indian runner ducks and wanted to make a piece with them in. Using that idea as a starting point, we found a photograph of a small group of runner ducks and combined it with a sketch of a watering can and snail. The three parts together worked beautifully – an example of the odd numbers rule explained on page 43 – and the piece told a story about the runner ducks, in the garden, eating the pesky snails!

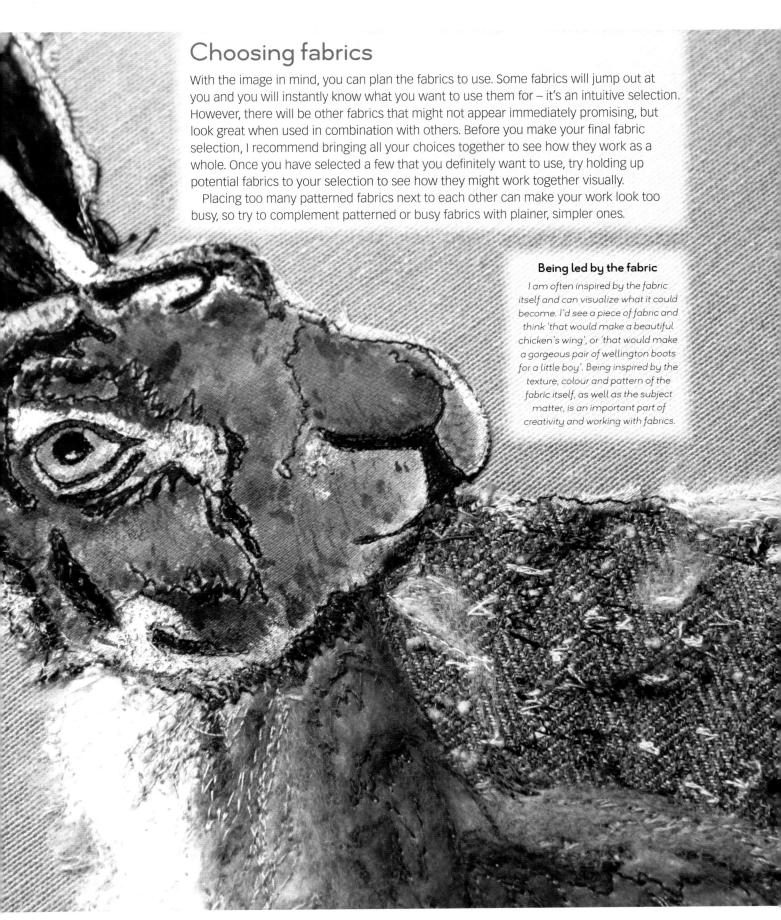

Choosing fabrics

With the image in mind, you can plan the fabrics to use. Some fabrics will jump out at you and you will instantly know what you want to use them for – it's an intuitive selection. However, there will be other fabrics that might not appear immediately promising, but look great when used in combination with others. Before you make your final fabric selection, I recommend bringing all your choices together to see how they work as a whole. Once you have selected a few that you definitely want to use, try holding up potential fabrics to your selection to see how they might work together visually.

Placing too many patterned fabrics next to each other can make your work look too busy, so try to complement patterned or busy fabrics with plainer, simpler ones.

Being led by the fabric

I am often inspired by the fabric itself and can visualize what it could become. I'd see a piece of fabric and think 'that would make a beautiful chicken's wing', or 'that would make a gorgeous pair of wellington boots for a little boy'. Being inspired by the texture, colour and pattern of the fabric itself, as well as the subject matter, is an important part of creativity and working with fabrics.

Composition

The way in which a piece is composed is very important. It dictates whether a piece is visually pleasing. Sometimes cutting out the individual items you'd like to include in your piece and then experimenting with their layout on a piece of paper is a good way to plan the most eye-pleasing positioning. The sewing collage project on pages 94–101 explores this idea.

The following are a few rules or guidelines to help you achieve a beautiful piece that attracts others.

The rule of thirds

Dividing your artwork into three by a grid of horizontal and vertical lines is a great way to help plan your work. Placing the focal parts of your image and points of interest somewhere along these lines is a surefire way to make your work stronger and more visually striking. The effect is heightened when you place the focal points where these lines intersect – these are called power points.

When looking at a work of art, your eyes are naturally drawn to these lines and power points. Laying your work out in this way helps bring balance to the composition as well as making the piece more engaging to the viewer's eye. This rule works with photography as well as artwork.

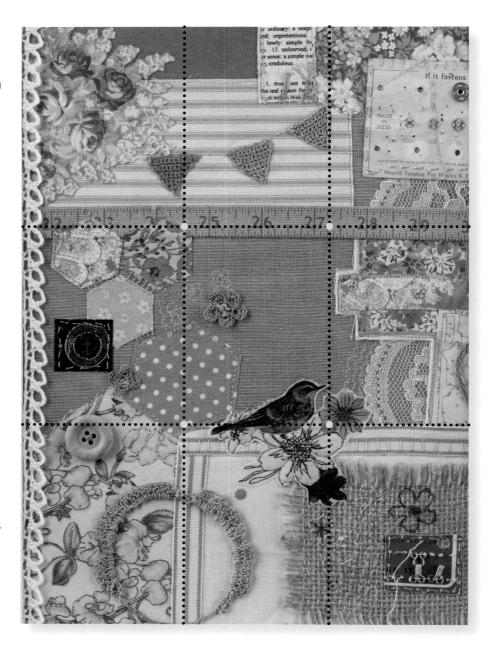

Vintage Collage

This composition shows good use of the rule of thirds. Note how the background is split into three main areas of top, middle and bottom, and the focal point – the bird and flowers – is placed on one of the four power points (marked in yellow) at the lower right. Rather than putting the main focus right in the middle, doing it this way leads to an imbalance to the piece, which helps to lead the viewer's eye around the image and keep their attention in a pleasing way.

Perspective

When using perspective in a piece, it is important to make sure that the things in the background are the smallest, that they are bigger in the middle and largest at the front in the foreground.

Texture in the foreground can also be a great way to give a sense of perspective and interesting detail to your work.

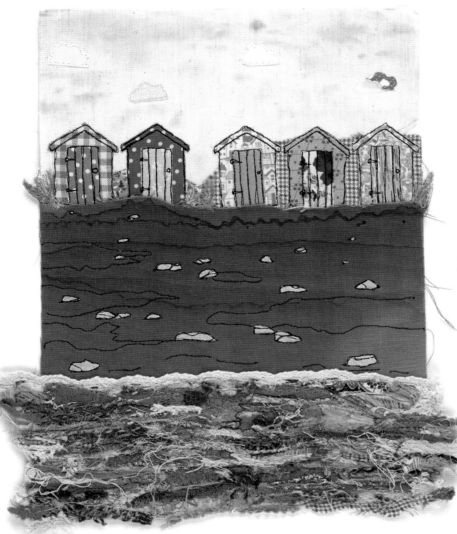

Beach Huts

Smaller beach huts in the background along with a heavily textured foreground sea help to give the impression that you are viewing the beach from the sea, perhaps in a boat.

Odd numbers

When you have multiples of something, aim to use odd numbers as these are more visually pleasing. Doing this also allows a central focal point and works with the rule of thirds.

In the examples below, you will notice that the families with three and five pairs of boots are more pleasing to the eye than the version with four pairs of boots. This is because even numbers give a static, still impression, whereas odd numbers inherently seem more unbalanced, creating an impression of dynamics that help them seem active and alive.

Family Wellingtons

These are a popular subject that I am often asked to reproduce on commission – a family portrait, with each person symbolized by a pair of wellington boots in the same colours as their real boots.

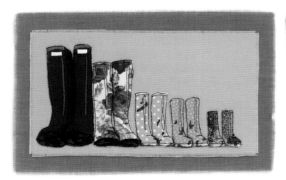
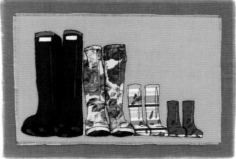
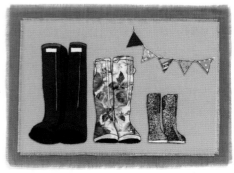

Colour

The colours that you use within your work will be totally individual to you, and likely based on what types of colours and fabrics to which you are drawn. Personally, I am a big fan of a full and bright colour palette, where I can really enjoy having fun with my colour choices.

Starting points

I usually start by selecting some fabrics for the main focal points, then select additional fabrics that go with these main fabrics to achieve a full and vibrant colour palette.

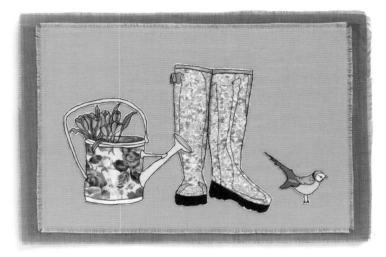

If I notice there is a colour that appears to be missing from the piece, but I can't put my finger on it, I work through the colours of the rainbow to see what might be missing and experiment adding in fabrics in those colours to see if that is the missing piece. I experiment with a range of potential fabrics until I have arrived at a visually pleasing colour palette: then I get to making.

For each of the upper two pieces on this page, for example, I started by selecting fabrics for the bird – the focal point – using the colours of a real blue tit. I next chose the fabric for the wellington boots by instinct – I was simply drawn to it. With these basic colours in place, I then chose the colours of the other fabrics, threads and paints to work with these and to fill out the colour palette. While the two are identical in terms of composition and design, the choice of colours gives a subtly different effect – which just goes to show that there is no one 'correct' approach to choosing colours.

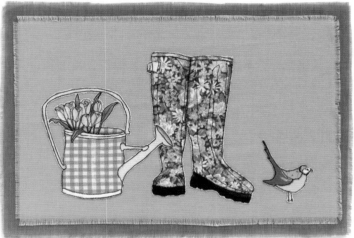

Fabrics and threads

In addition to varying your fabric colours, experiment with the colours of your threads too. Aim for something that will show up on your appliquéd fabrics – either lighter or darker. To test the thread against your appliqué fabric choices, take one strand of the thread and lay it across all your fabrics.

If the artwork has a real mix of colours, sometimes black is the best shade to use as it will show up on all the fabrics and can help tie the piece together, as in the example of the sofa to the right.

Using either one coloured thread for the whole piece or many different colours within the piece could work well, so try both options.

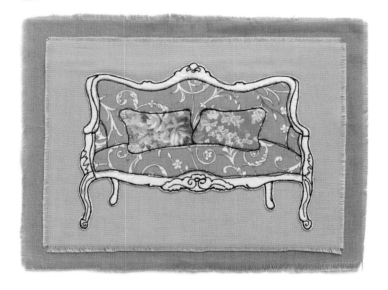

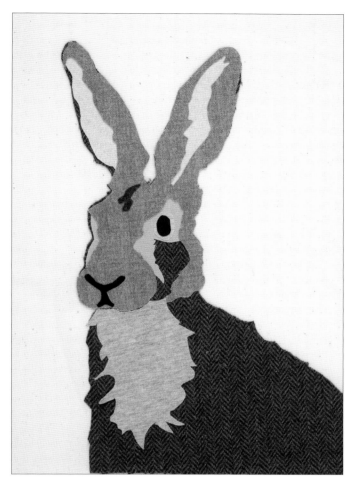 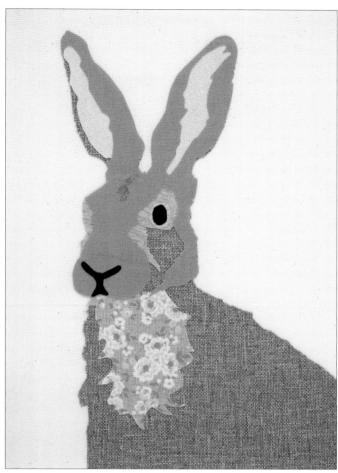

Your personal palette

When walking into a fabric shop, I am sometimes drawn to slightly more subdued colours, erring toward the pastel rather than my usual full-on bright colours. However, I tend to team my more subdued colours with a 'pop' of brighter colour here and there as I believe this brings the best out in both colour palettes. I often find the subject matter determines the colours and fabrics that I will use within a piece; but I do try to have some fun when the colour choice is completely up to me.

I encourage you to use the colours and tones that you are attracted to within your pieces, to make each artwork truly your own. It's great to experiment too and push yourself out of your comfort zone now and then with your colour choices as well as the techniques you use, as this will help you to grow as an artist. You may even find something that works beautifully that you never would have tried before!

Naturalistic colour schemes

The colour scheme you choose might seem dictated by the subject matter – browns and greys for the hares above, for example. Both show the same hare design in two different colour schemes. Both are natural and inspired by the colour a hare could truly be, along with the textures within the fabrics – but do bear in mind that there's nothing stopping you from choosing very different colours from reality, if that's what you want to try.

Background

The background of a piece plays a very important role in each artwork. The backing needs to complement and enhance your fabric artwork, not distract or detract from it. As mentioned earlier, I often use a neutral backing, as I find it helps to tie in my colour palette, and helps to make the pastel colours I favour to stand out more. Sometimes a stark white background can be too harsh where a neutral can often hit the sweet spot.

The texture of the background is also important, as picking an overly textured or even patterned fabric can make a piece look too busy and distract from the subject matter.

These examples show the same piece on different backings – wood painted to look like a simple landscape; wood painted white; and a neutral fabric background. Note how the colour and texture of the background affects the appearance of colour and helps to set off the piece.

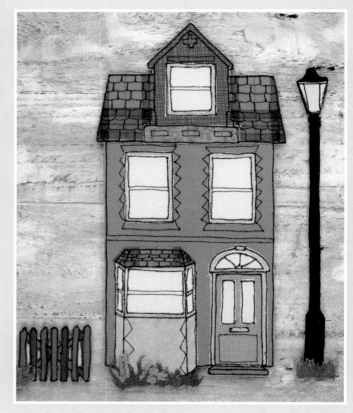

46

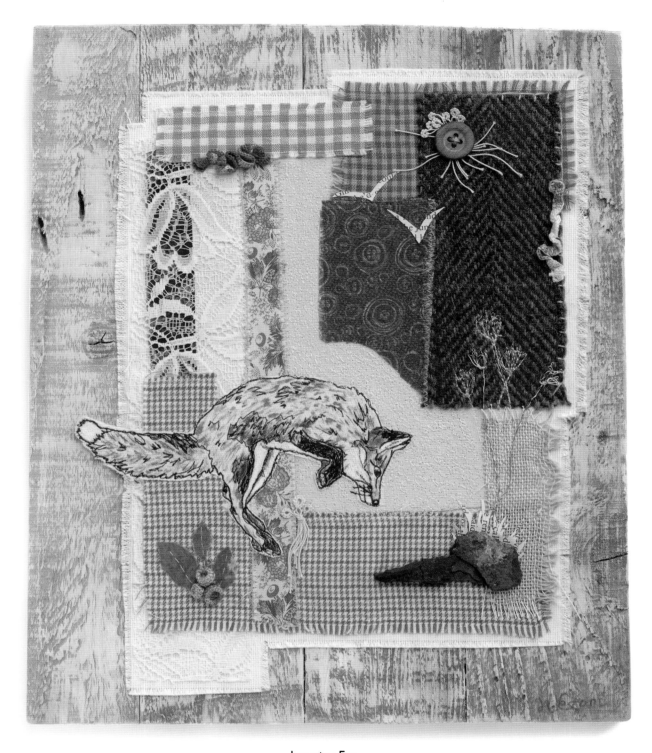

Jumping Fox

This piece came together organically, much like putting together a jigsaw puzzle. I started with the fox in the foreground – the focal point – making it with freehand machine embroidery and painting it with inks. I then collaged a background from smaller pieces of fabric, experimenting with their placement.

Once the background looked good, I then started to incorporate my found items: small pieces of crochet, tatted loops, wire work, small paper pieces and a little piece of rusted iron and, as before, experimenting with the placement of each item, until the piece looked 'right'.

You can see the rule of thirds in play in this piece, through the placement of the focal points and the way in which the background has been built up.

Appliqué Hare

I love how elegant and majestic hares can look, their ears pricked up and alert to their surroundings. I believe this piece has captured that elegance and regal look. In this lifelike adaptation, the use of fabric layers combined with stitch lends itself beautifully to represent one of nature's beauties.

This project teaches you how to use templates together with fusible webbing to achieve accurate appliqué. Together with using pattern paper for correct positioning, this technique starts you off with the perfect fabric base on which to add all the details with free machine embroidery. To vary the image, do please experiment with your fabric and colour choices. As explained on the previous pages, your fabric choice does not have to reflect the natural colours of a hare. Have some fun adding in some more stitched fur lines and details, either using more freehand machine embroidery or hand stitch for some added textures.

You could even create yourself a lovely grassy foreground and have the hare peeking above it, by using some of the techniques and textures described later on in the book.

YOU WILL NEED

Equipment:
Sewing machine, embroidery foot, needle, bobbin
Iron and ironing board
Ballpoint pen
Large and small fabric and paper scissors
Sticky tape
Pins

Materials:
Medium weight calico or a similar weight piece of fabric for backing – at least 27cm x 38cm (10½ x 15in)
Pattern paper
Iron-on interfacing
Fusible webbing
Cartridge paper
Appliqué fabrics
Machine thread

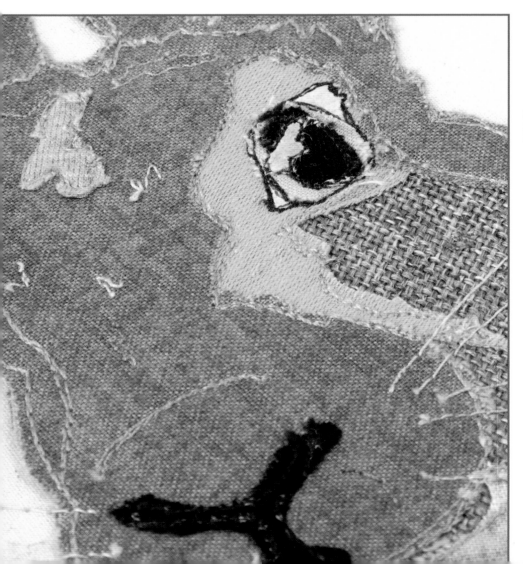

Detail from the finished piece.

Opposite:
The finished piece

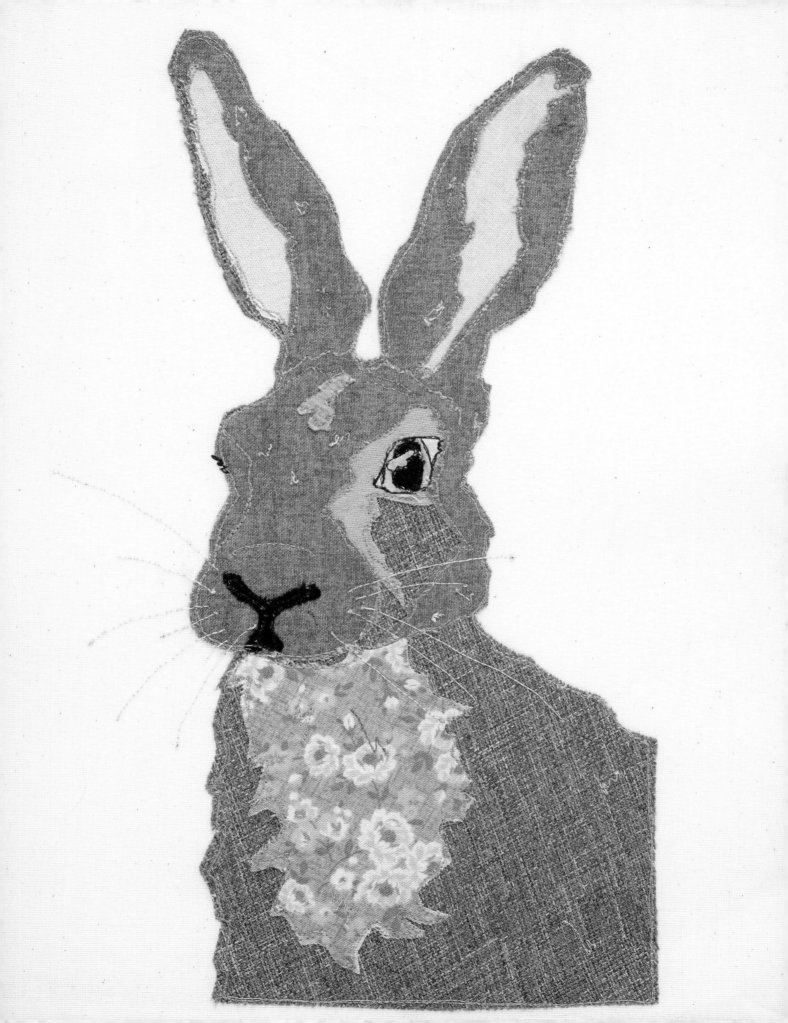

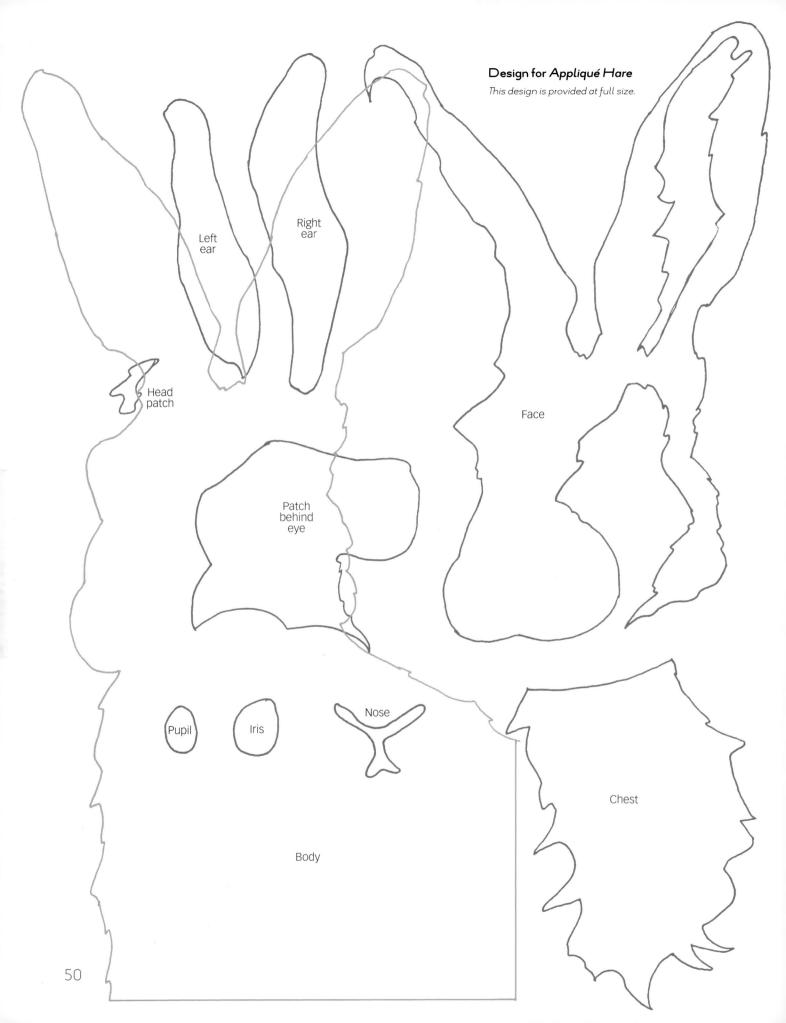

Design for *Appliqué Hare*
This design is provided at full size.

Left
ear

Right
ear

Head
patch

Face

Patch
behind
eye

Pupil Iris Nose

Chest

Body

50

Appliqué templates

This stage gets all the shapes prepared for you to use later.

1 Cut a piece of your backing fabric larger than the design, with about an 8cm (3in) or more margin around each edge. Cut a piece of iron-on interfacing a little smaller than the backing fabric and iron it onto the back of the backing fabric.

2 Trace the templates onto a plain piece of cartridge paper. Copy all labels, numbers or directions. Cut out the templates accurately with a small, sharp pair of paper scissors

3 Place your heat-fusible webbing on a hard surface, smooth (paper) side facing up and the textured (glue) side facing down. Place each template one by one, onto the heat-fusible webbing – importantly, the right side should be face down.

4 Trace around the edge of each template in turn using a black ballpoint pen. Leave at least a 5mm (¼in) gap between each template drawn on the heat-fusible webbing. Make sure your lines are drawn boldly.

TIP

If the glue starts to separate from the paper backing of the webbing, place a couple of pins through both layers to secure it together before cutting out.

5 Cut out each template, leaving a 2mm (⅛in) margin past the drawn line – cutting right up to the lines means that the fusible webbing piece will become smaller and then becomes too small for the design.

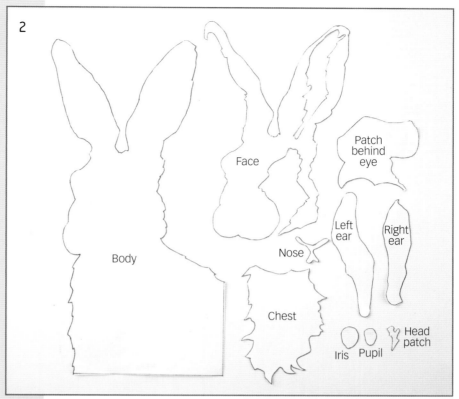

Face

Patch behind eye

Left ear

Right ear

Nose

Body

Chest

Iris Pupil Head patch

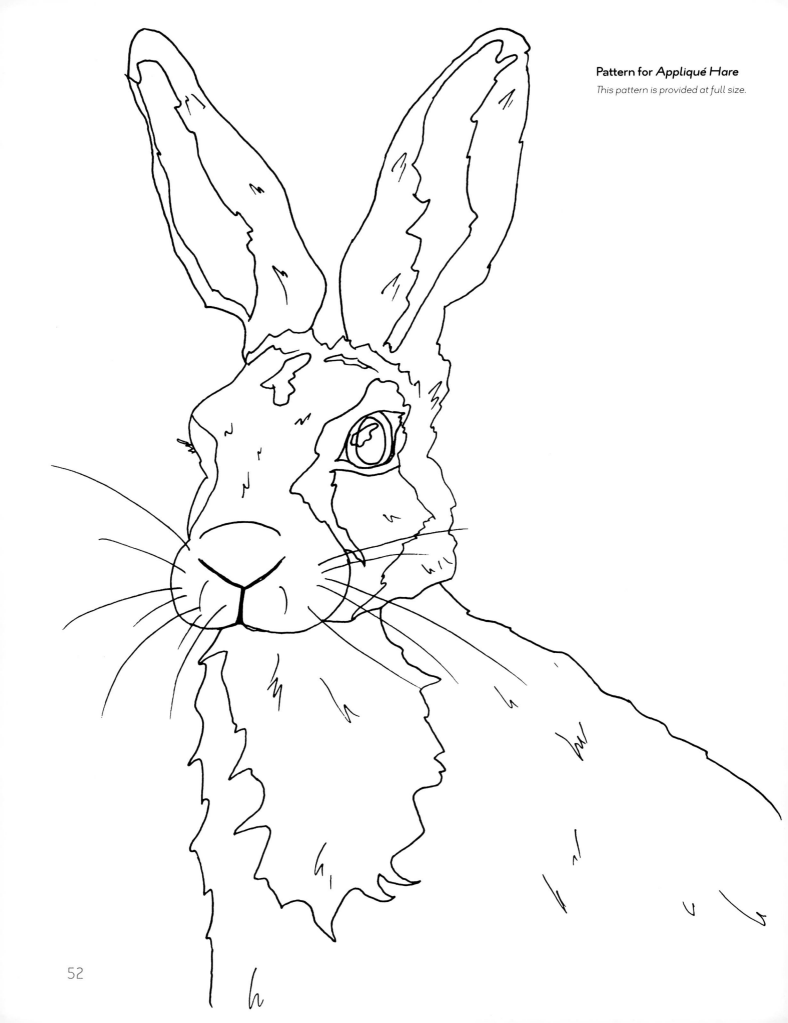

Using heat fusible webbing

You will now need to pick your appliqué fabrics for each part of the hare. In total, you will need eight fabrics: one piece for the body, one for the chest, one for the face, one for the patch behind the eye, one for both ears, one for the little patch on the head, one for the iris (coloured part of the eye) and a black for the nose and the pupil of the eye. I used linen for the body, jersey for the patch on the head, and cotton for all the others. You can experiment with the colours you use, or simply copy those I've used here.

6 Working one at a time, place your chosen fabrics face down on the ironing board. Take the correct fusible webbing piece and lay it on the back of the fabric, textured (glue) side down, smooth (paper) side up, with your pen lines facing towards you. Use an iron to press the template down, at full heat for about six to eight seconds. The fusible webbing's backing paper will turn translucent when it has adhered.

TIP

Don't rush: the thicker the fabric, the longer it will take to secure the fusible web properly. Use a piece of backing parchment or scrap fabric to help protect your iron from the fusible webbing.

7 Roughly cut out your template pieces, making sure you remove all the fusible webbing from your main fabric piece.

8 Neatly cut out just to the outside of your pen line – leave a gap of 1mm or so outside the line.

Transferring the design

9 Leaving at least a 5cm (2in) border around the design, cut a piece of pattern paper to size then trace the hare pattern (opposite) onto the paper using a ballpoint pen.

10 When the drawn pattern is complete, pin the top two corners of your pattern paper onto the front side of the backing fabric (i.e. interfacing on the back), so the design is facing you.

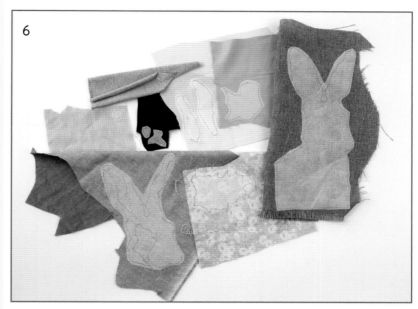

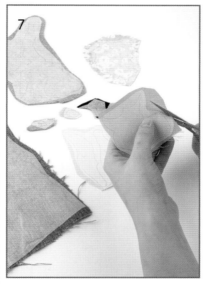

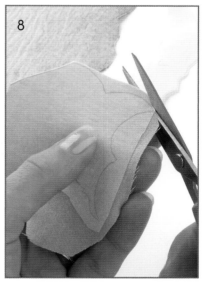

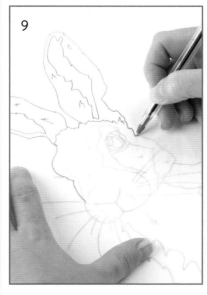

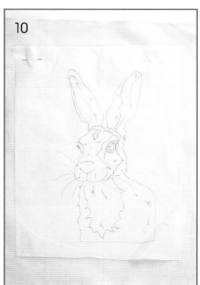

Appliqué placement order

You will now iron the pieces in place, working from the background to the front. Don't worry if the fact that you have drawn and cut the piece a few times means that it does not fit perfectly under the pattern; these lines can be redrawn a little later.

If you find the paper backing is not peeling off from the fusible webbing easily, it may be that the glue hasn't completely adhered to the fabric – try re-ironing the fusible webbing onto the fabric, waiting for it to cool, then trying to remove the backing again.

TIP

To help start removing backing paper from the fusible web, go to 'rip' the piece of prepared fabric. The paper will rip and give you somewhere to start pulling the paper off, but the fabric itself won't tear.

11 Peel the paper backing from each small appliqué piece one at a time, starting with the body of the hare.

12 Once the backing is removed, lift the pattern paper aside and place the body of the hare onto the backing fabric, near where it needs to go.

13 Lower the pattern paper to check the positioning is correct, and adjust the fabric piece until it lines up with your drawn lines on the pattern.

14 Iron the piece in place at full heat for six to eight seconds.

15 Wait for the fabric to cool before positioning the next appliqué piece – the patch behind the eye. Peel off the backing, then position using the pattern paper (see step 13). Secure with the iron.

16 Repeat for the ears. You can secure both at the same time.

17 Secure the chest in the same way.

18 Secure the face, positioning it over the patch behind the eye and the ears.

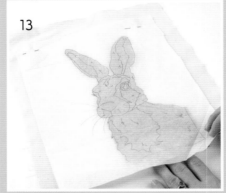

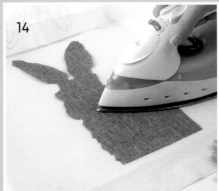

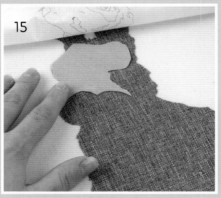

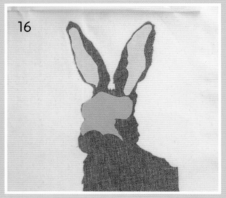

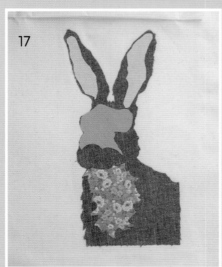

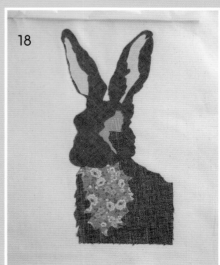

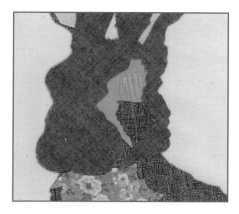

19 Add the iris in the same way, on top of the patch as shown.

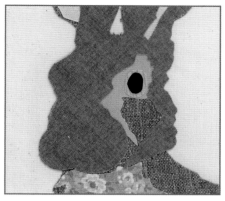

20 Place and secure the pupil in the centre of the iris.

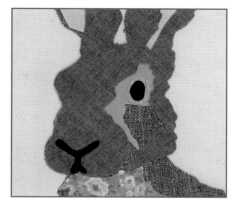

21 Iron on the nose.

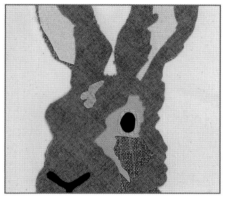

22 To finish the appliqué, add the patch in the centre of the head.

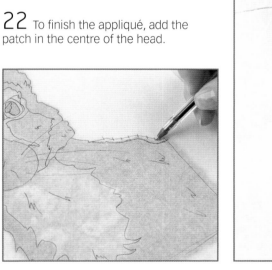

23 Once all the pieces are secured, lay the pattern paper down and pin the two bottom corners in place. If there are any pen lines that are out of place, use the ballpoint pen to redraw them so they fall just inside the edge of the appliqué fabric piece. Cross out the old line to make it clear which is correct.

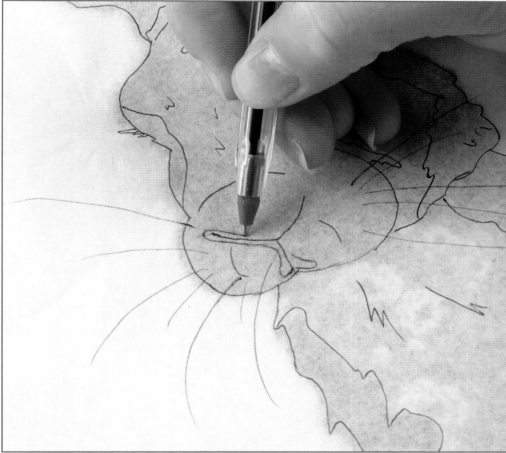

24 Following the outline of the appliqué, draw round the nose – this is a convenient way to ensure accuracy on such a small, detailed piece.

Stitching

Choose your colour thread for stitching. Take one strand of thread and lay it across your appliqué to help you decide whether the colour is right and can be seen clearly on your chosen appliqué fabrics. I suggest starting your stitching at the bottom; somewhere a little hidden or out of the way.

25 Put your fabric with the appliquéd design and paper pattern pinned down under the foot and lower the needle using the hand wheel into the fabric where you wish to start. See pages 30–31 for the technique of stitching lots of small details more efficiently

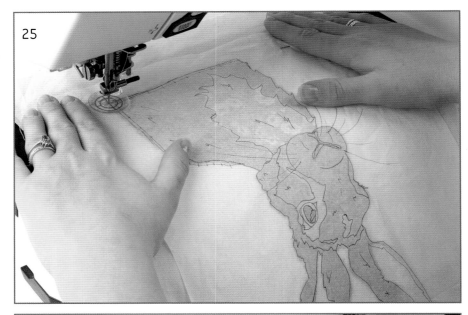

26 Sew around the edges of all your fabric pieces and over your lines, stitching once around the main outline. Try to find your way around all the lines on your hare without having to stop and start again.

27 As you stitch all the lines a second time, it is a good time to go into the middle of the hare's body and stitch the chest and the details on its face.

TIP

If you feel uncomfortable stitching the facial details like the eyes using freehand machine embroidery, this can instead be done either partly or entirely by hand (e.g. back stitch), using the same machine thread.

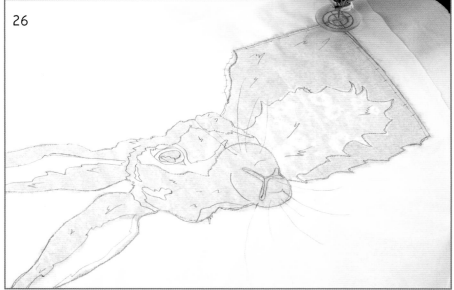

28 Now stitch small fur details on your hare. The easiest way to do this is to stitch each small hair line twice and when you have finished, lift your needle up and pull the fabric into position ready to stitch the next fur line. Lower the needle into the fabric and stitch on the next fur zigzag line. You can cut all the threads in between when you have finished stitching.

TIP

If you are unsure how many times you have stitched around your piece, look at the back to see your stitched lines without the pen lines getting in the way.

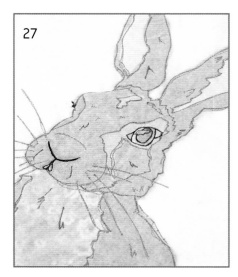

Removing paper

Now you have finished all your machine embroidery it is time to remove the paper and reveal your textile art! Remove the pins, then snip all the threads on the front of the piece.

29 The double stitched lines will have nicely perforated the paper which should mean it comes away easily. Grip the pattern paper near the outside of the hare.

30 Tear the paper at a 45-degree angle from the stitching, to give an accurate and clean rip.

31 Using your fingers, start removing all the bits on pattern paper on top of the fabric.

32 For the shine in the eye, I have left a little of the paper inside the stitched lines, then removed all the other tiny pieces of paper from in between the stitched lines. This can be a bit fiddly and will take a little while, but using tweezers or a stitch unpicker to help scrape the little bits out will make the process quicker.

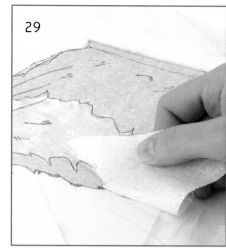

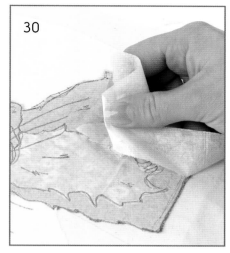

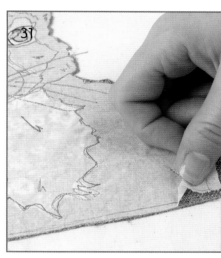

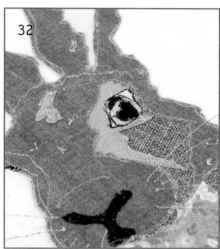

TIP

A sticky lint roller is a great tool to help clear up all those little bits of paper. You can also shake the finished piece over a wastepaper basket to get rid of them.

A larger version of the finished piece can be seen on page 49.

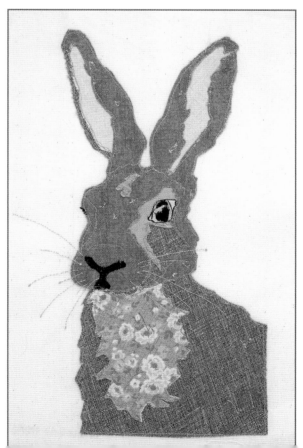

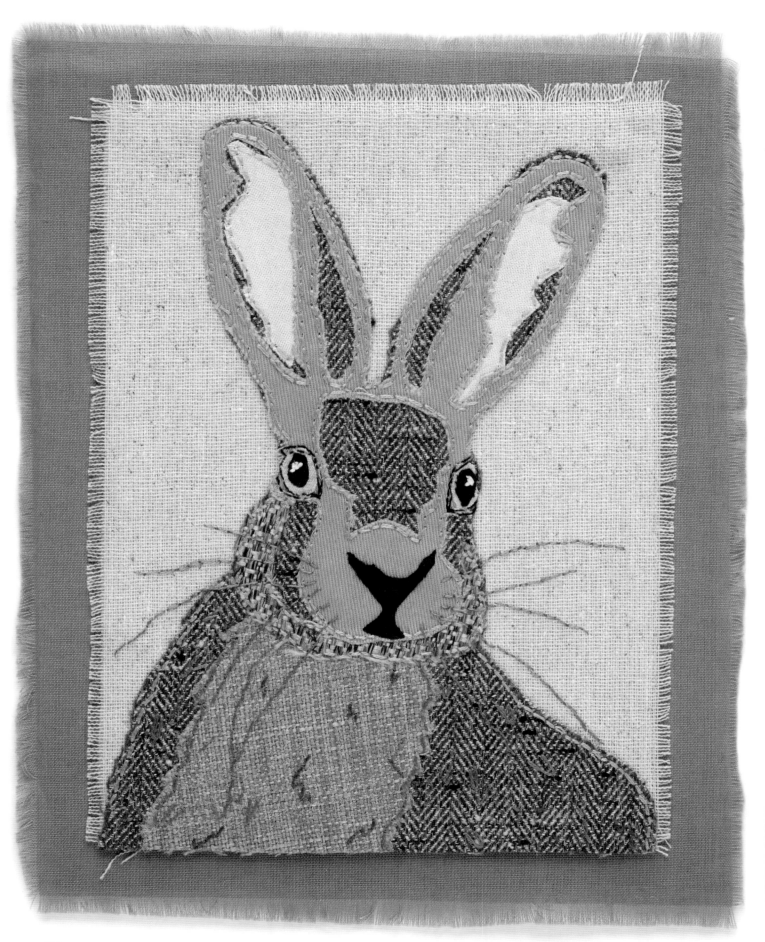

Appliqué and Hand-embroidered Hare

This variation shows examples of using hand embroidery to add in some detail and more texture. Feel free to add in anything else you'd like: make the piece your own. You can use groups of French knots, running stitch, chain stitch or whatever you think would enhance your piece.

TIP

Once finished, your pieces can be mounted and framed, or made into a cushion, bag or anything else you can think of.

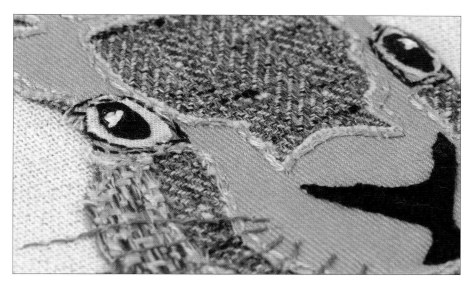

Face and eyes

Note the white flecks in the eyes, giving a 'sparkle of life'. Unlike the rest of the piece where I used two strands to give bolder stitching, I used only one strand of silk to stitch around the small, delicate eyes.

Texture in the fur

Zigzag lines not only suggest the direction in which the fur lies but also to add a realistic texture. Adding in some hand embroidery to your freehand machine embroidered textile art creates still more texture and detail.

Ears

The pink fabric inside the ears gives a lovely flash of colour to the piece.

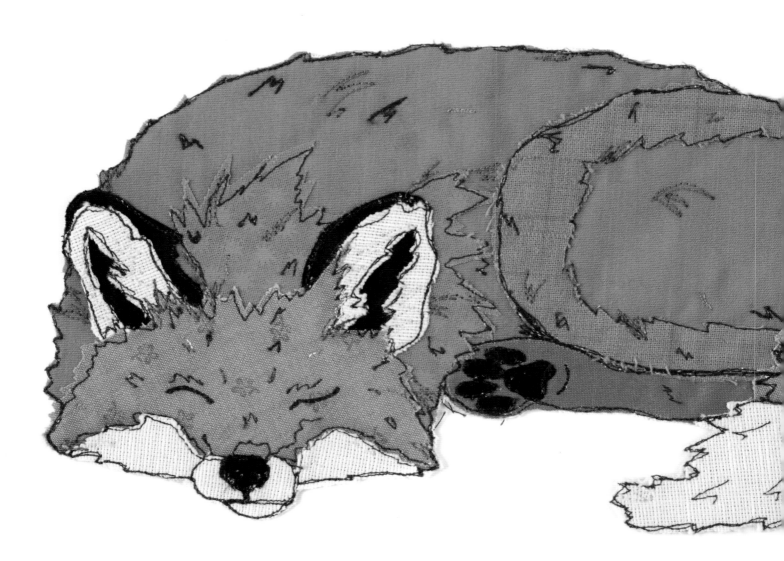

Sleeping Fox

In terms of the techniques used – freehand machine embroidery and appliqué –
this piece is similar to the hare. It also shares the same naturalistic colour palette.
Where the pieces differ is in the texture, which has been created here using a
'zigzag' line around the edge of each appliqué piece to really capture the fluffy
fur of the fox. The piece has also been cut away from its backing fabric when
stitching was complete. While it is complete as a standalone piece of fabric art
at this stage, you could take it further by re-mounting it on another backing or
perhaps on a bag or cushion.

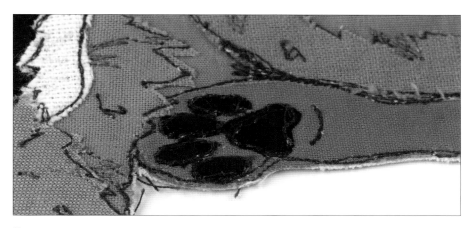

Paw

Paying attention to make sure tiny little details are accurate helps to bring the piece to life and make it more realistic.

Ear

A two-tone ear, slightly hidden behind the fur from the face. The order in which appliquéd layers are placed is vital, especially when they overlap like this, and is an important thing to think about when planning your piece.

Chequered fabric

Having fun with the fabric choices is important. I felt this one brought a little English country charm to the piece.

Paint and stitch

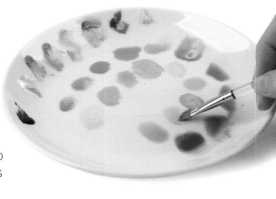

Preparing acrylic paint

Prepare all the mixes you want to use before you start, so that you don't have to stop part-way through to re-create the mix. Keep similar colours together as this makes it easier and quicker to find the correct hue when blending.

1 Squeeze out a small amount of each colour you want to use on the edge of a plate.

2 Pick up a little of the first colour paint on your brush and wipe it near the centre of the plate, then add water to dilute it. Rinse the brush, then repeat with each colour in turn.

3 Prepare the mixes in various different consistencies; some with more water, some with less. When shading, start with the most dilute, then strengthen as necessary. Add white to tint the colour (i.e. make it lighter in tone) or add water for a more subdued tone.

Preparing watercolour paint

Watercolour sits slightly on top of the surface, so you need to work it slightly more into the fabric. However, it blends more readily than acrylic paint.

TIP
When using watercolour paints, do not water them down too much, as doing so will mean the paint is more likely to bleed. In addition, less water will mean a more vibrant colour.

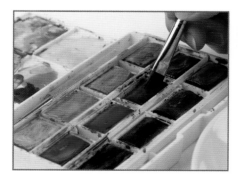

1 Wet the brush and draw it across the colour you want to use, two or three times to load the brush.

2 Take the brush over to your plate and deposit the colour near the centre. Repeat a few times to build up a small pool of prepared paint, then rinse your brush and repeat with the next colour.

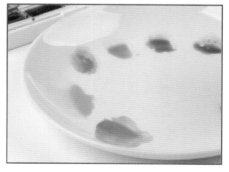

3 Rather than adding white to tint the colour (as with acrylics), simply add more water to the paint to achieve lighter tones with watercolour.

Techniques and tips

I recommend having a 'play' with your paints on a piece of spare fabric before using them within your piece. Use this time to help familiarize yourself with how the paints work on fabric rather than paper.

Experiment with the amount of water needed to get the paint to flow on the fabric, the different amount of pigment needed with each paint type and paint colour – especially black!

Look at blending, colour mixing and the way differently-textured materials can take the paint differently; which will all lead to even more texture. Enjoy!

TIP

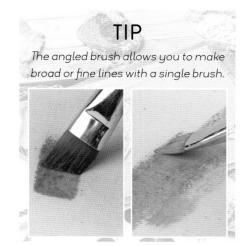

The angled brush allows you to make broad or fine lines with a single brush.

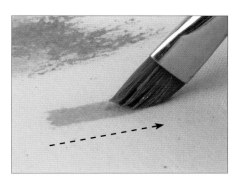

Work backwards

Draw the angled brush 'backwards' as shown to give you more control.

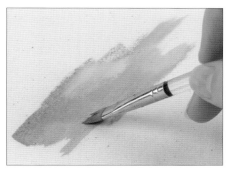

Blending

Your paint needs to be fairly dilute to apply smoothly to the unprimed fabric and avoid patchy coverage. Additional colours should mix or blend smoothly together with wet paint on the fabric.

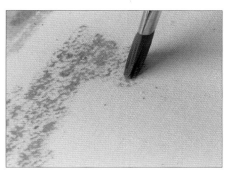

Stippling

Repeatedly 'tapping' the point of the brush on the surface is called stippling. It produces a distinctive dotted, textural effect.

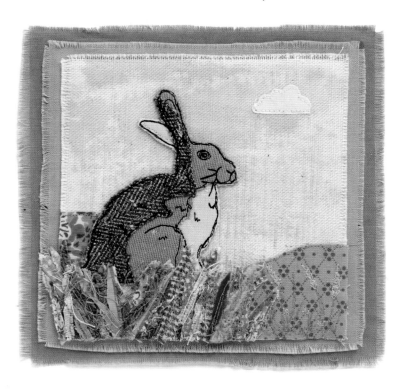

Wild Hare

In this piece a background fabric of cream linen was painted with watercolours before the appliqué pieces were added.

Blue Tit

This project introduces paint alongside your free machine embroidery. Using paint as a base instead of appliqué within your textile art can be a lovely way of achieving a different and more subtle effect to your work. You can use fabric paints for this, but personally I find watercolour and acrylic paints easier to come by, cheaper and with a much wider variety of colours available.

Before diving right in and painting with paints on fabrics within this project, I recommend looking at the previous pages for how to use these types of paints on fabrics, and having a 'play' on a piece of calico to experiment and familiarize yourself with how the medium behaves when used on fabric, and how much water in relation to pigment will be needed.

When ironing a painted piece of fabric you may wish to use a piece of scrap fabric to protect the paint work from the iron, especially when you iron on the front (i.e. the painted side) of the fabric.

Remounting is another technique used within this project. This can be used to build layers very effectively, and is a particularly good way to add a relief effect to artwork. In turn, this allows your subject matter to stand out even more from the background fabric.

YOU WILL NEED

Equipment:
Sewing machine, embroidery foot, needle, bobbin
Iron and ironing board
Ballpoint pen
Large and small fabric and paper scissors
Sticky tape
Pins
Angled and small paintbrushes
Water pot
Palette (a white plate is perfect)
Kitchen paper

Materials:
Medium weight calico or a similar weight piece of fabric for backing, 34 x 42cm (13¼ x 16½in)
Neutral-coloured linen or similar fabric, 20 x 29cm (8 x 11½in)
Teal cotton or similar coloured fabric, 28 x 37cm (11 x 14½in)
Iron-on interfacing
Fusible webbing
Watercolour paint in green, blue, purple, yellow, pink, white and brown
Machine threads

Opposi
The finished pie

64

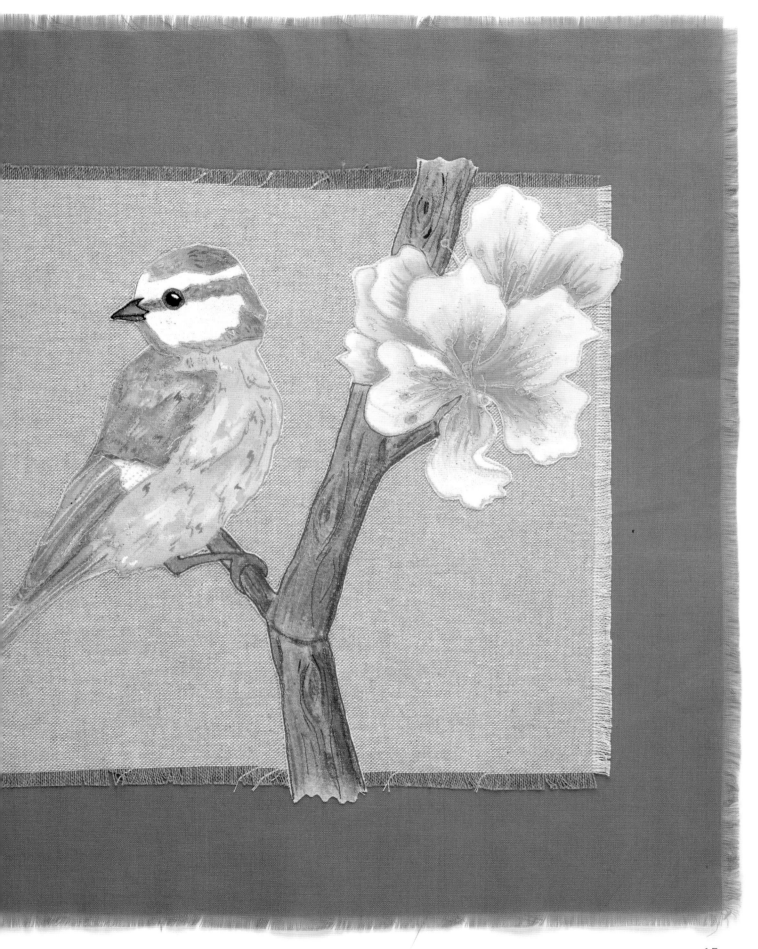

Design for *Blue Tit*
This design is provided at full size.

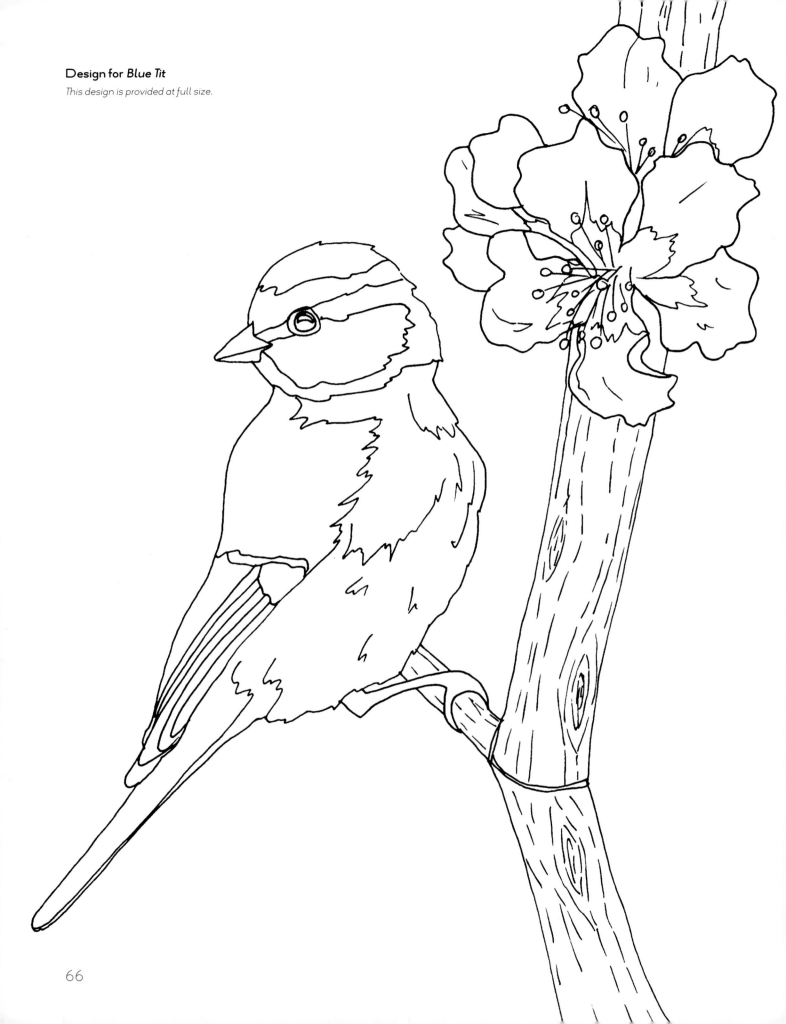

Preparing the fabric and painting

The backing fabric you use is important; it needs to be thin enough that you can see the lines of the design through the fabric. I have used a medium weight calico.

In this example I have used watercolour paints, but acrylic paint could be used instead. For in-depth instructions on preparing your paint and tips on painting on fabric, refer to the painting techniques section on pages 62–63.

1 Cut a piece of calico larger than the blue tit design, with a margin of about 8cm (3in) all around. Place the calico centred over the blue tit design and hold in place with a small piece of sticky tape. With a black ballpoint pen, start to trace through the design, just as though using pattern paper.

2 Continue until you have traced the entire design. Work carefully, making sure you get all the subtle lines. If you are having any difficulty seeing the design's lines to trace, try holding the design page up to a window or using a light box.

3 Prepare paint mixes on your palette for the blue tit, branch and flower.

4 Paint the base colours – the first layer of paint – by carefully massaging the watered-down paint into the fabric. Start with the wing, as this is a relatively large, smooth area in which you can practise blending the light and dark tones.

5 There is no particular order in which to work beyond starting with the lighter colours and working towards the darker. Continue until the whole piece is painted with a varied first layer as shown.

6 After the first layer of paint has dried, use a small brush to paint in the second layer, adding in the details: feathers, highlights, shadows, bark texture and flower flecks.

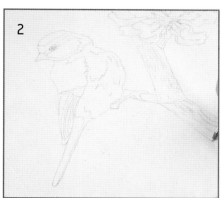

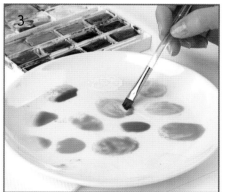

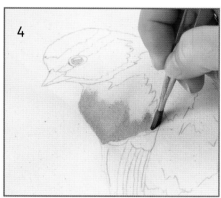

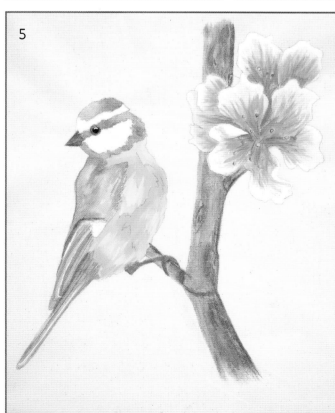

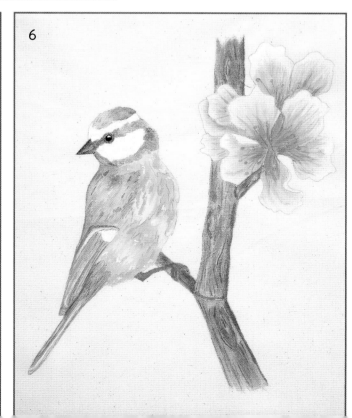

Free machine stitching

Pick some complementary-coloured threads to stitch your piece in. Pick ones dark or light enough to stand out on your paint work, but that still blend and work nicely within your colour palette – avoid any that are too overbearing. When combined with paintwork, the stitching works well if it's a little more subtle, as this leads to a more natural look. Choose a range of coloured threads, some for the outlines and a mix of lighter and darker colours for the details.

7 Cut a piece of iron-on interfacing just a bit smaller than the piece of calico, but larger than the blue tit design. Make sure all the paint has dried and you have added in all the details in paint you wish before laying it over the image.

8 Use an iron to secure the iron-on interfacing onto the back of the calico.

9 Stitch around the outline of the image in a complementary colour, one that will show up, but also blend into the piece.

10 Change the colour thread when you need to; for example, I have used blue around the blue areas, and yellow around the yellow and so forth.

11 Stitch in the details such as feathers, bark lines and flower petal veins – stitch over all the pen lines you have drawn and feel free to add in any extra stitched detail you wish. You can experiment with shading and stitching freely in this project, adding in highlights and lowlights as you wish to complement the paint.

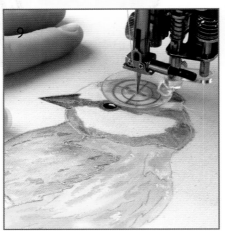

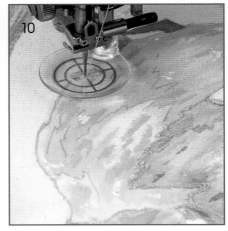

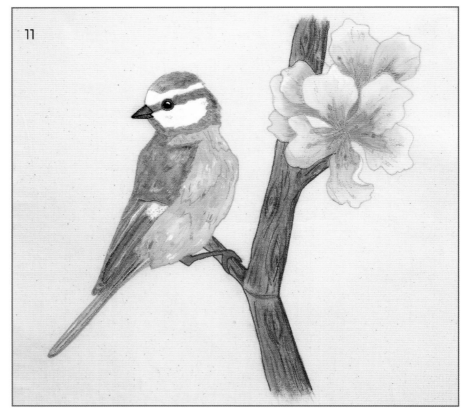

Remounting

We now cut out the design and remount it on a piece of fabric. Be aware that the more fabric layers you are ironing through, the longer you will need to iron the piece to get the fusible webbing glue to adhere. You may also wish to iron the piece from the rear side too.

12 Iron a layer of fusible webbing on the back side of the piece, covering the whole design. Because you are going to cut out the image, there's no need to use a single large piece; you can use a 'patchwork' of webbing offcuts, so long as the whole design is covered.

13 Carefully cut the design away from the rest of the background fabric. Go as near as you can to the stitched lines without cutting them. A pair of small, sharp fabric scissors will help a lot.

14 For each of the raw ends of the branch, where the paint fades to nothing, cut an organic, wiggly shape, rather than a straight line.

15 Cut rectangles of your neutral linen and teal cotton fabrics – the linen should be just a little smaller than the cut-out blue tit on the branch, with a slight overlap on each side. The cotton should be larger, with a 3–4cm (1–1½in) margin round the edge of the linen.

16 Fray the linen by pulling loose threads until you end up with an 8mm (⅜in) fringed border.

17 From the back of the painted and stitched blue tit, remove the fusible webbing paper backing and position in the centre of the linen fabric. Place a piece of scrap fabric or tea towel over your design and iron in place.

18 Iron a layer of fusible webbing on the back of the linen. When cool, remove the fusible webbing's paper backing and place the piece in the centre of the cotton. Protect your design with a piece of scrap fabric or tea towel and iron it in place. Flip it over and iron the back side of the piece (again with fabric to protect the paint) to ensure the fusible webbing has completely adhered.

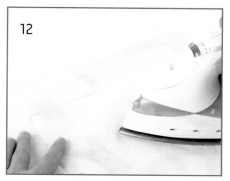

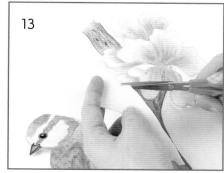

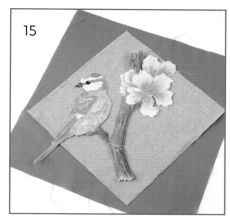

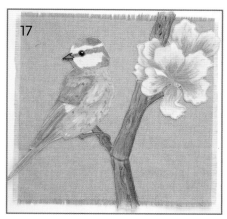

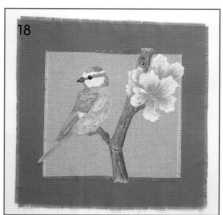

A larger version of the finished piece can be seen on page 65.

TIP

For extra stability, you can attach a layer of cardboard to the back using a thin layer of fabric glue.

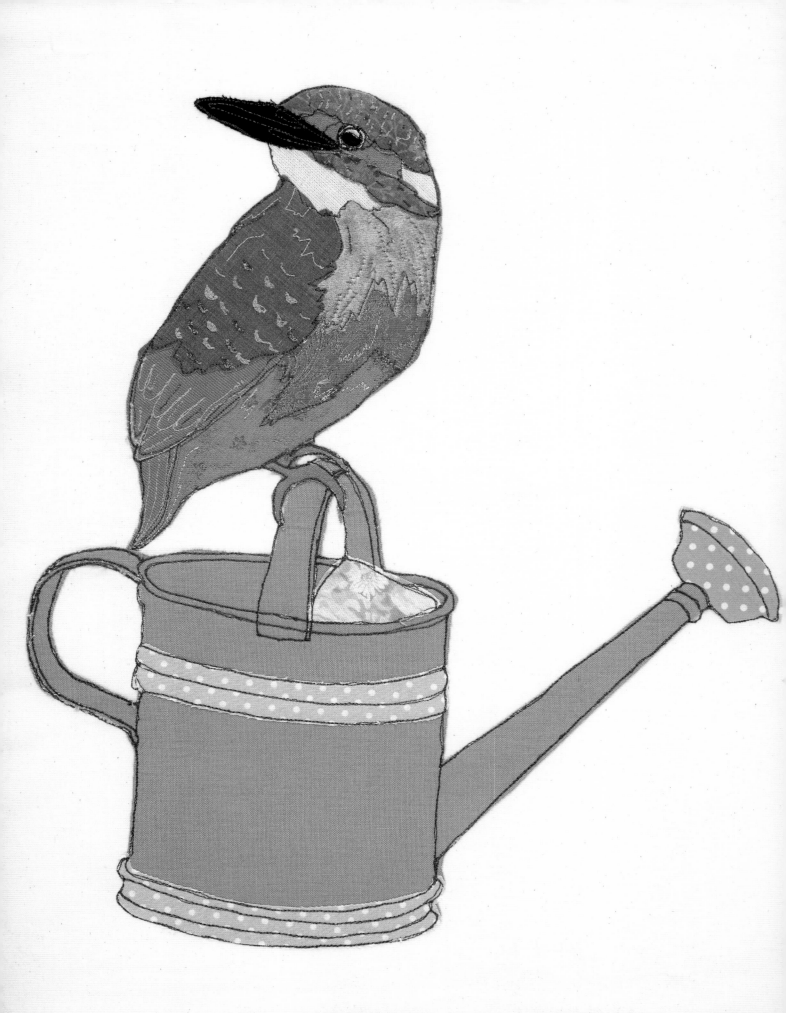

Kingfisher

This free-machine embroidery and appliqué kingfisher gave me a great place to experiment with texture and colour within the piece. With the kingfisher's iridescent feathers, I was able to use some interesting fabrics to achieve a shiny, lifelike feel to the some of the feathers.

Velvet

Fabric textures can really enhance a piece. This velvet not only adds a lustrous shine, but also a lovely silky and touchable texture.

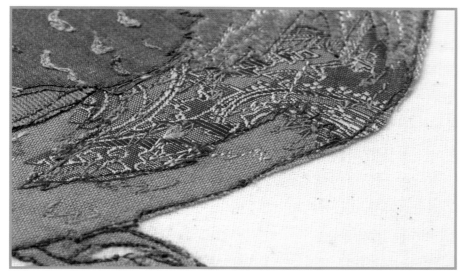

Silk

Small areas of intensely coloured and patterned fabric can add a great splash of colour and detail. Along with the metallic and shiny nature of this fabric, the paisley silk piece here really draws the eye and catches the light.

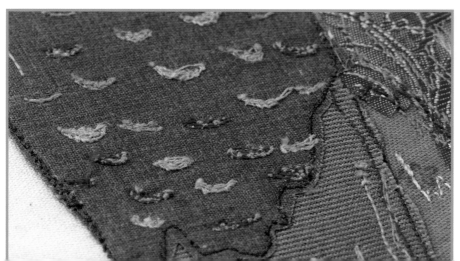

Feathers

Using heavy stitching to suggest small details like these feathers is another way to incorporate and build up texture.

They work especially well when they are used on a slightly plainer piece of appliquéd fabric, as the extra stitching doesn't get lost in an overly patterned fabric.

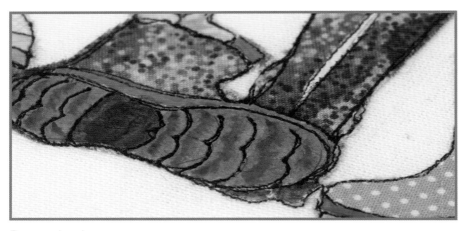

Painted soles

Small painted details work very well when combined with an appliqué base. They bring out the best in both the appliqué and paintwork.

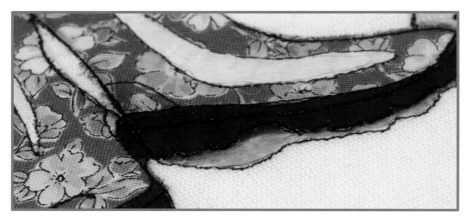

Shadows and fabric

Paint can add depth and detail to a piece that is impossible to achieve through fabric alone. It gives the piece a more three-dimensional feel.

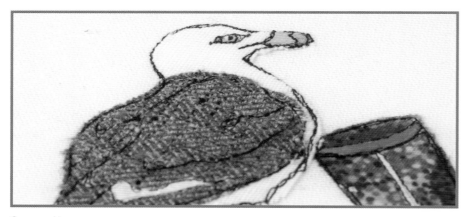

Seagull

Paint was used to colour the small areas of the seagull, its eyes and beak. This works perfectly as cutting out tiny pieces of fabric for these two areas would not only have been too fiddly but could have looked a little messy.

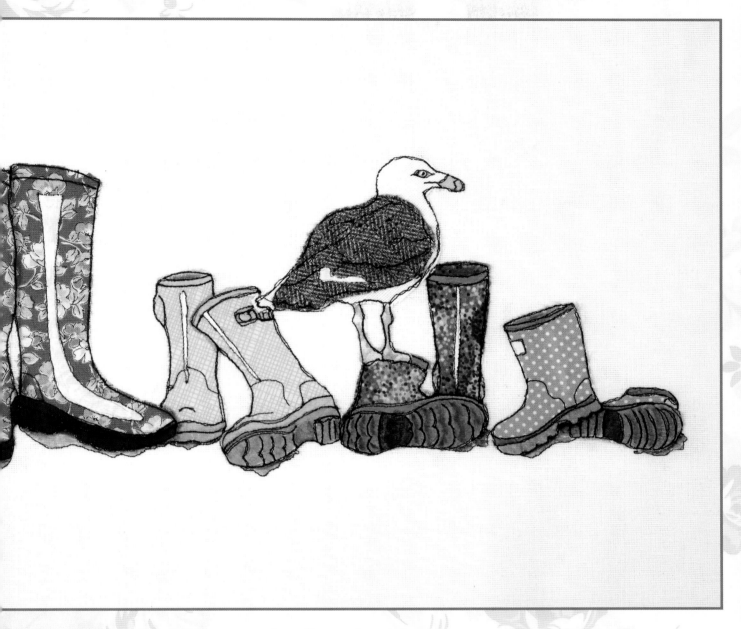

Family of Wellies at the Beach

With all of my signature 'welly portraits' I aim to capture the beautiful chaos of family, especially with kids, showing the boots strewn on the floor.

I now live next to the sea on the south coast of the UK, and wanted to add a new feature to my wellington boot portraits – enter the seriously cheeky nature of the seagull, who always seems to appear just where you don't want him!

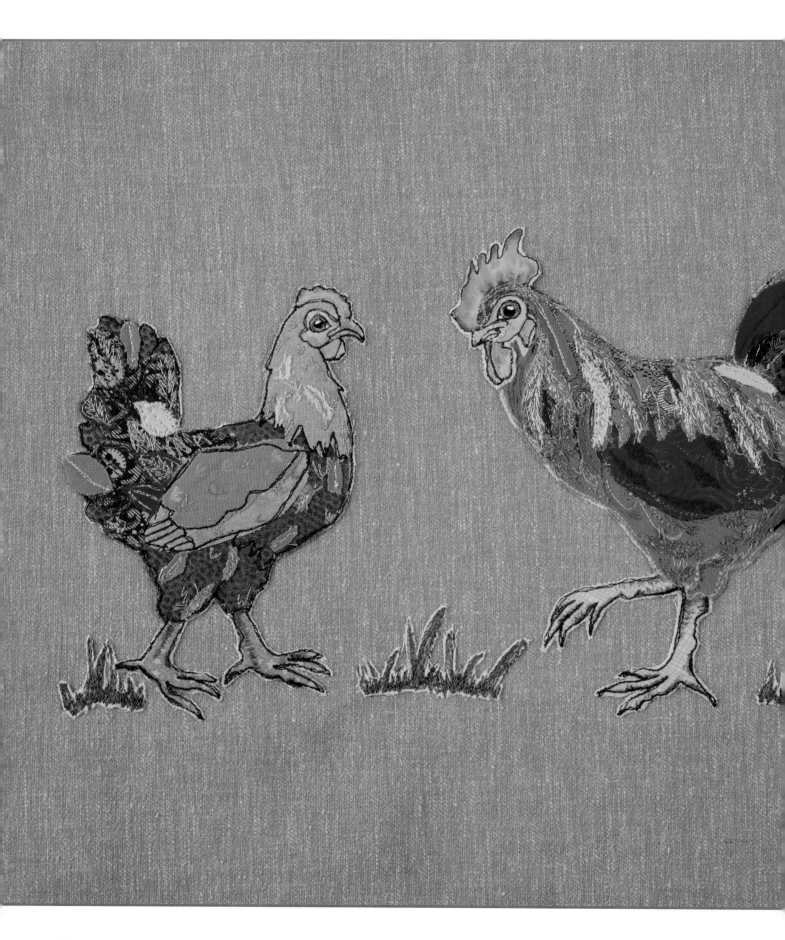

Hen and Rooster

This project combines the techniques that you have learnt so far in a new and exciting way. Freehand machine embroidery, appliqué and painting, this time with the addition of couching, are all used within this project to help you achieve more texture within your pieces. Using these mixed media techniques to their best within your pieces helps to create lifelike yet fun pieces.

You can bring this sense of freedom and enjoyment into your fabric choices – have fun with your fabric choices: try adding in some colour and pattern splashes here and there.

This piece allows you more freedom within your stitching; while retaining the security and accuracy of the pattern paper design. We will use the pattern paper to position all the appliqué pieces as before and to stitch all the important details. However, we will then remove it, to allow some more organic freehand machine embroidery of the feathers of the chicken and rooster. Removing the paper also gives us space to incorporate some lovely couching for a great splash of texture and colour.

I find working this way can often give you the best of both worlds, the accuracy of the pattern with the flow and freedom of adding in the more flexible details and textures.

YOU WILL NEED

Equipment:
Sewing machine, embroidery foot, needle, bobbin
Iron and ironing board
Ballpoint pen
Large and small fabric and paper scissors
Sticky tape
Pins
Angled and small paintbrushes
Water pot
Palette (a white plate is perfect)
Kitchen paper

Materials:
Medium weight calico or a similar weight piece of fabric for backing, at least 35 x 26cm (13¾ x 10¼in)
Blue linen backing fabric, at least 40 x 30cm (15¾ x 11¾in)
Appliqué fabrics
Couching fabrics
Cartridge paper
Iron-on interfacing
Fusible webbing
Acrylic paint in pinks, peaches, reds, browns, ochre
Machine threads

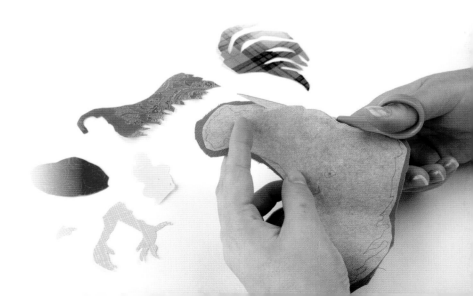

Opposite:
The finished piece

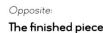

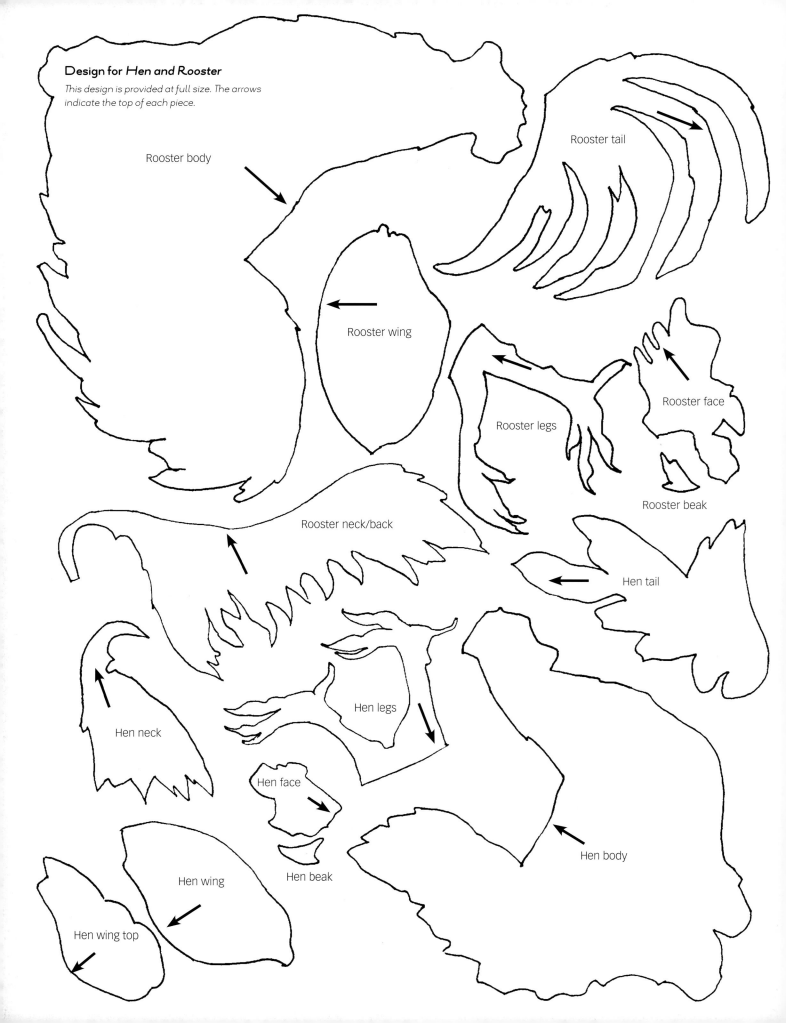

Design for *Hen and Rooster*

This design is provided at full size. The arrows indicate the top of each piece.

Rooster body

Rooster tail

Rooster wing

Rooster legs

Rooster face

Rooster beak

Rooster neck/back

Hen tail

Hen neck

Hen legs

Hen face

Hen body

Hen wing

Hen beak

Hen wing top

Chickens

To help decide on the colours for your chickens, try laying scraps of fabric directly down on the design to see how they work together.

1 Cut a piece of your backing fabric larger than the design, with a margin of 8cm (2in) or more around each edge. Cut a piece of iron-on interfacing a little smaller than the fabric and iron it onto the back of the piece.

2 Trace the templates opposite onto a plain piece of cartridge paper, copy all labels, numbers or directions. Cut out the templates accurately with a small, sharp pair of paper scissors.

3 Place your fusible webbing on a hard surface, paper (smooth) side facing up and the glue (textured) side facing down. Working one by one, place each template right side face down onto the fusible webbing and accurately trace around the edge with a black ballpoint pen. Make sure your lines are drawn boldly and leave a small gap between each template drawn on the fusible webbing.

TIP

If the fusible webbing glue starts to separate from the paper backing, place a couple of pins to secure the two together before cutting out.

4 Cut out each template with a 2mm (⅛in) margin past the line – it is best to cut the template a little larger at this point: if you cut into the lines at this point the fusible webbing piece will become smaller as you continue, potentially becoming too small for the design.

5 Pick your appliqué fabrics for each part of the hens, you will need one piece for faces of both, one or two for the legs and beaks, two for the hen's wing, one for the rooster's wing, one for the hen's neck, one for the rooster's neck/back, one for the body of the hen, one for the body of the rooster, one for the tail of the hen, and one for the tail of the rooster.

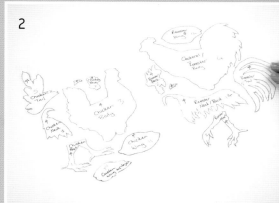

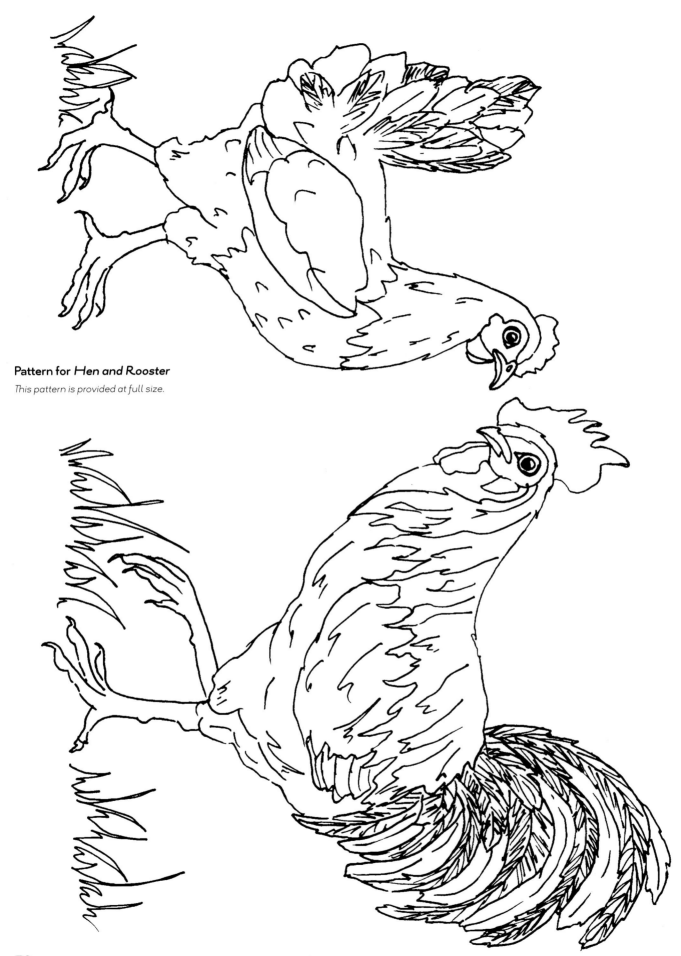

Pattern for *Hen and Rooster*

This pattern is provided at full size.

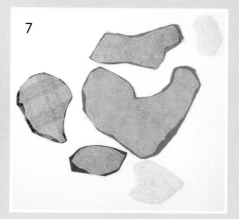

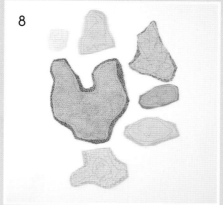

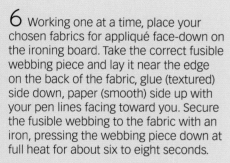

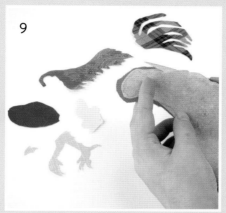

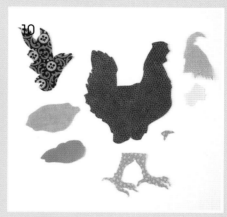

Preparing the pieces

Using small sharp scissors to cut out these small and detailed appliqué pieces will really aid your progress and accuracy.

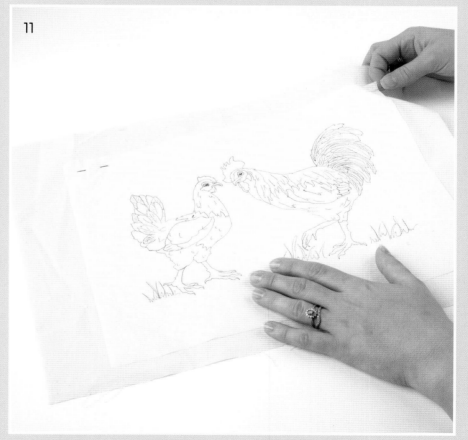

6 Working one at a time, place your chosen fabrics for appliqué face-down on the ironing board. Take the correct fusible webbing piece and lay it near the edge on the back of the fabric, glue (textured) side down, paper (smooth) side up with your pen lines facing toward you. Secure the fusible webbing to the fabric with an iron, pressing the webbing piece down at full heat for about six to eight seconds.

7 Roughly cut out the pieces for the rooster, making sure you remove all the fusible webbing from your main fabric piece so that you do not leave any fusible webbing on your large fabric piece: this can lead to a very sticky iron later on!

8 Repeat for the hen.

9 Neatly cut out all of the pieces of the rooster, just outside of the pen lines.

10 Again, repeat for the hen.

11 Cut a piece of pattern paper to size, 5cm (2in) or so larger than the pattern (see opposite). Use a ballpoint pen to trace the hen and rooster pattern onto the paper. Pin the top two corners of your pattern paper onto the front side of the backing fabric.

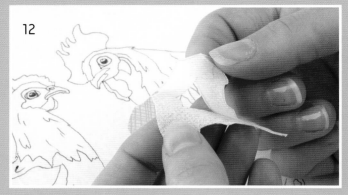

Appliqué order

When building up the appliqué in this piece, you work one piece at a time, from the background to the front.

12 Starting with the legs of the hen and rooster, peel the paper backing from the appliqué piece.

13 Once the backing is removed, place the legs of the rooster onto the backing fabric under the paper. Place the piece roughly where it needs to go, then lower the pattern paper and adjust the fabric piece until it lines up with the lines on the pattern.

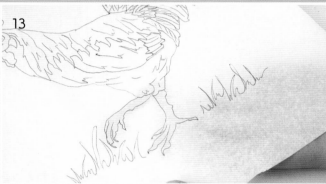

14 Lift the pattern paper out of the way and iron the piece in place at full heat, for six to eight seconds.

15 Do this for each piece in the following stages: the legs of the hen, then the bodies of the chicken and the rooster. Remember, work one piece at a time.

16 Next, add the tails to the hen and rooster, before repeating the process to secure the faces of the hen and the rooster.

17 Secure the larger wing of the hen.

18 Add the smaller part of the wing on the hen, then the wing of the rooster.

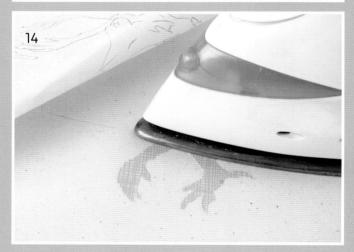

19 Still securing one piece at a time, secure the necks and backs of the hen and rooster.

20 The last stages of appliqué are the beaks of both the hen and rooster.

21 When all the pieces are secured, place the pattern paper down and pin the two bottom corners in place. If there are any pen lines that are out of place, redraw them so they fall just inside the edge of the fabric piece. This is most important when the line falls on the backing fabric. Cross out the old lines to make it clear which ones are correct.

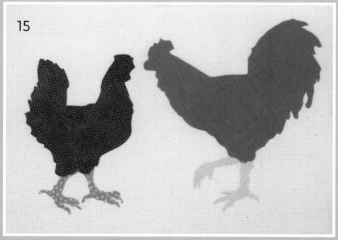

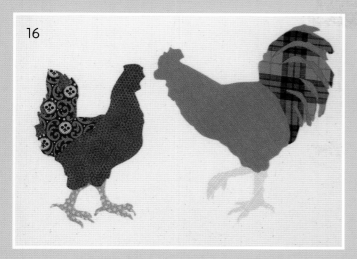

16

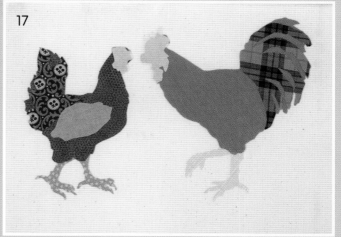

17

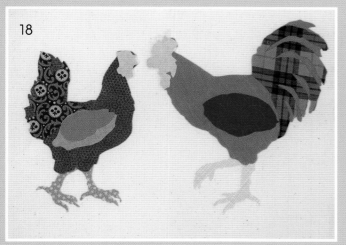

18

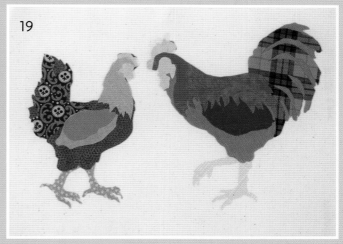

19

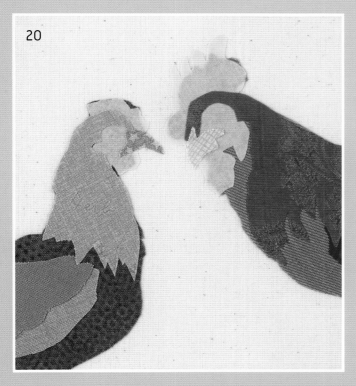

20

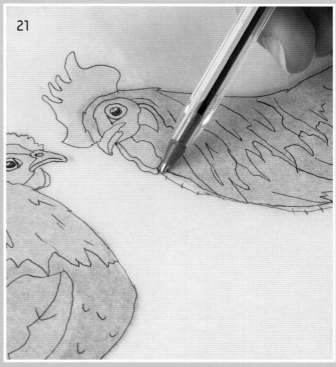

21

Stitching and removing paper

This time the stitching process will be a little different, as we will stitch the main outlines and face, then rip the paper away for some more free stitching to add in details and texture.

Before you begin, take one strand of your chosen thread and lay it across your appliqué. This will help you decide whether the colour is right and can be seen clearly enough on your chosen appliqué fabrics. Feel free to use more than one colour.

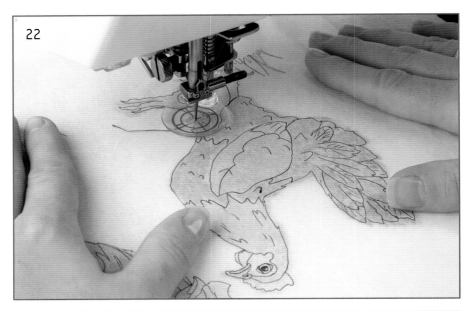

22 Put your piece under the foot and use the hand wheel to lower the needle into the fabric where you wish to start. I suggest somewhere a little hidden, as shown here.

23 Stitch twice around all the main outlines, bodies, legs, wings, faces and once over the grass outline. Please use as many different colour threads when stitching round the outlines as you wish. I have used different brown tones for the chicken, green for the grass and a beige for the rooster, teamed with a dark brown for his face and legs.

24 Take your piece from the machine and check the stitching. If you are happy, snip away any thread on the front.

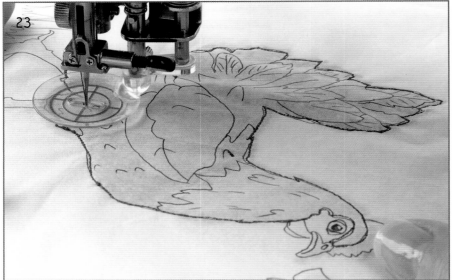

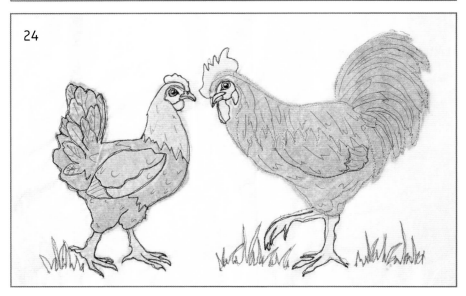

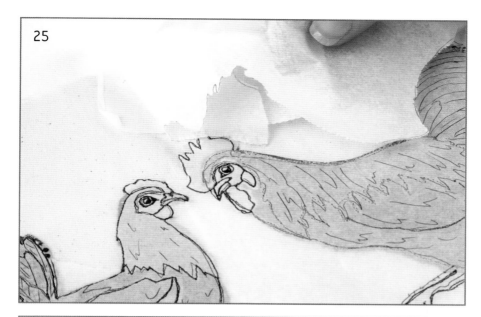

25 Remove the pins and start to tear away all the paper, starting from around the birds.

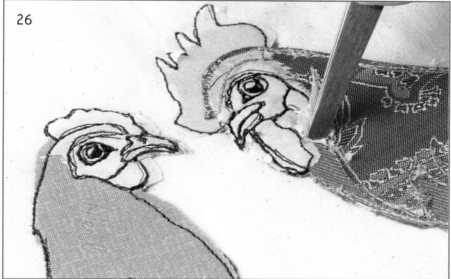

26 Use the tweezers to remove the pieces of paper from on top of the birds themselves, leaving it around the faces, as shown.

This is the piece with all the appliqué complete, along with the first part of the freehand machine embroidery.

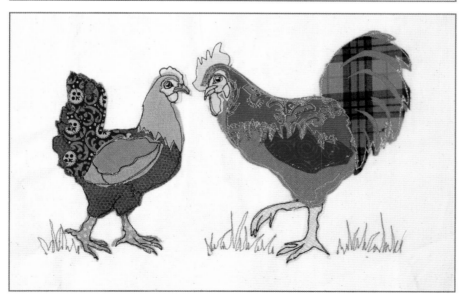

Couching

Couching is a technique where small pieces of fabric, yarn, silks or other types of materials are laid across the surface of a base fabric and fastened in place with stitch. The small pieces of fabric add life and interest to your work.

It is a great technique to use when you want to add more texture to your textile art.

27 Add a few small stitched feather details on your birds by stitching the shapes twice. Use the curve of these feathers to suggest the shape of the bird. I have used red for these feathers.

28 Add a few more free embroidery feathers over the same areas, varying the colour depending on the fabric underneath. I have used a metallic gold for some sparkle.

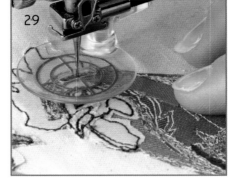

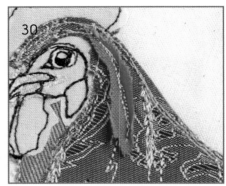

TIP

Rather than lifting the piece out and trimming each feather in turn, lift your needle up after each feather, then pull the fabric into position to stitch the next feather, then lower the needle and continue stitching. You can cut all the threads left in between once you have finished stitching all the feathers in a particular colour.

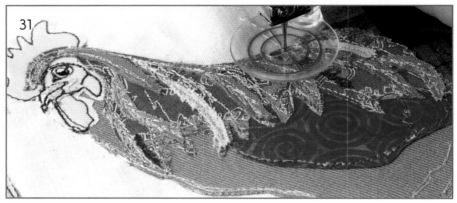

29 Cut out small feather-shaped and -sized pieces of fabric in complementary colours. Place them on top of your piece where you wish to attach them. Lower your needle with the hand wheel so that it goes into and through one end of the feather. Hold the other end with your finger so the fabric feather is taut and flush with the textile art.

30 Slowly stitch down the centre of the feather towards your finger. When you have worked all along the length and reached the end, stitch back to where you started – so you have two lines of stitch.

31 Add as many couched feathers as you like along the rooster's back. Try using feathery lines of stitching as well as straight ones, for added variety.

32 Add more free machine and couched feathers on the rest of the rooster, and on the hen. Remember that the tail feathers will be longer on both, particularly so for the rooster. Stitch into the grass using different shades of green and filling in the lines you have already stitched; I recommend using about three different shades of green thread.

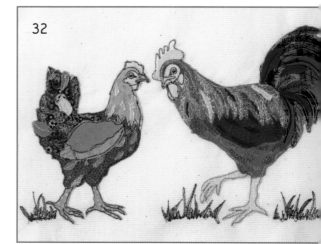

Painting and mounting

If you need a little refresher on the basic painting techniques, see pages 62–63.

Work gradually as you paint the birds. Start with a more delicate, less pigmented, paint and water mixture and then work in more if you want. Work in layers, and remember that it is best to start subtle, then increase, as you can't make your painting less subtle once it's done!

33 Use a variety of warm yellows and browns to paint the legs of both birds.

34 Add in more painted feathers, shadows, light flecks and more with the same colours, and introduce some pinks and light reds for the heads. Develop the eyes using gold mixed with brown for the iris, black for the pupils. Once the paint underneath is completely dry, add a small dot of white for reflected light.

35 Once completely dry, iron a layer of fusible webbing on the back of the birds, being careful to cover the whole of your design.

36 Cut out your work, as close to the stitched lines as possible without cutting into them. Cut out chicken, rooster and grass pieces all separately.

37 Cut your new backing fabric to 40 x 30cm (15¾ x 11¾in). Using a scrap piece of fabric over the top of the pieces to protect them, and working one piece at a time, remove the paper backing from the fusible webbing, position the chicken, rooster and grass on the backing and iron in place with full heat to finish.

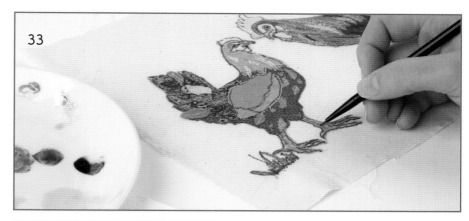

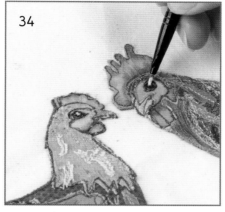

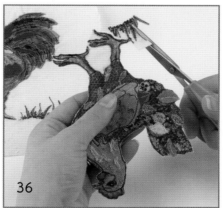

A larger version of the finished piece can be seen on pages 74–75.

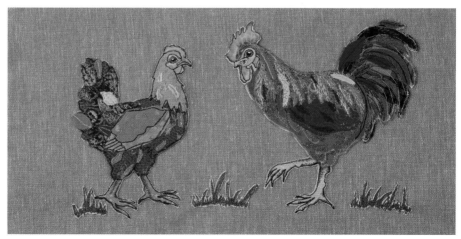

Three Chickens

This piece was made in a very similar way to the project on the previous pages; incorporating painted and couched details and textures, along with the freehand machine embroidery and appliqué.

 I really do have a thing for chickens. The process and the texture that can be achieved with textile art makes fabric the perfect medium to capture the lovely likeness of these beautiful subjects.

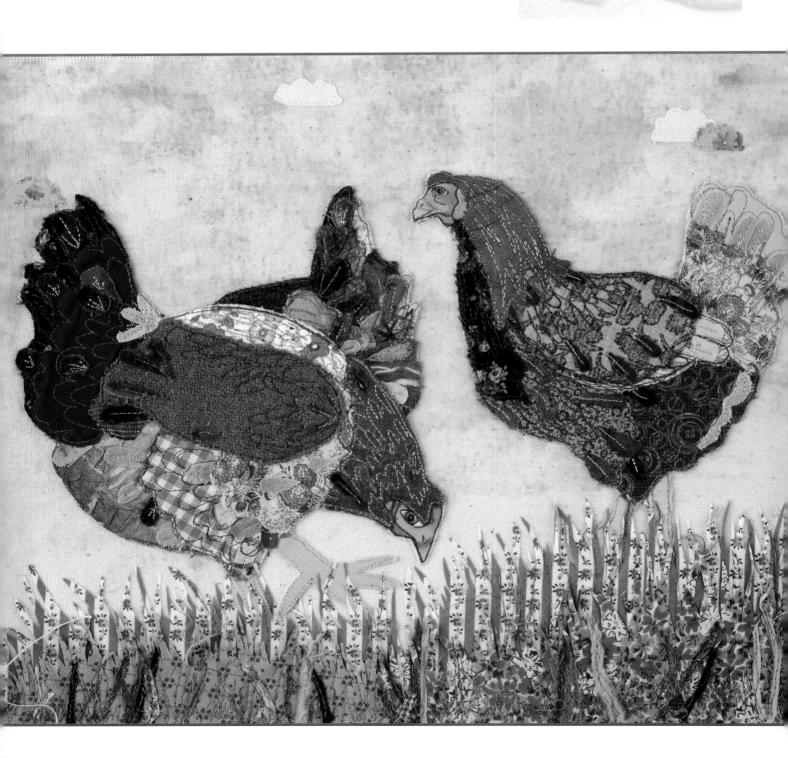

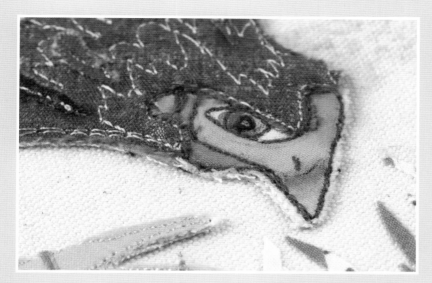

Painted face

Painting the faces of the chickens allows you to add more detail than could be achieved with appliqué alone. It also allows for a more subtle and realistic effect to the birds.

Feather texture

Couching in feathers on top of an appliqué layer is a technique I love using to add more texture and intrigue into my work. The way the material is held down only by stitching, rather than fusible glue webbing, allows it to stand proud of the appliquéd background.

Stitching and painted sky

A lightly painted background fabric can be another point of interest. Subtly adding in hints of colour using a gentle palette of colours and a stippling effect with the brush adds texture and a hint of colour to the background fabric, especially if you are using a white or cream.

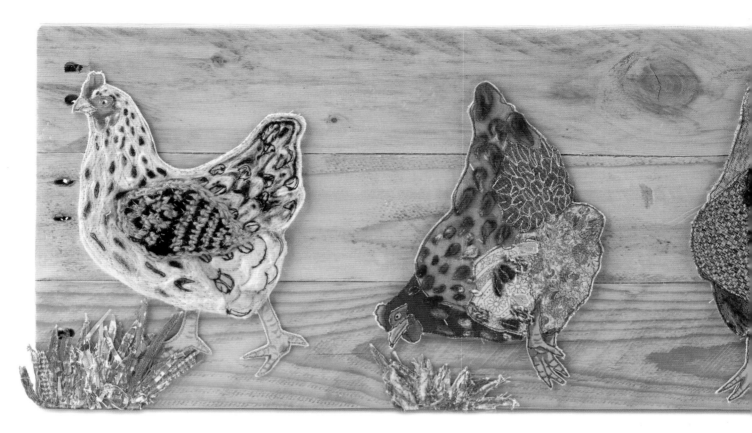

Five Hens

I had a lot of fun making this piece, in which I was aiming for something a little different. I played with the sizes, shapes and textures I used, and enjoyed allowing the textures out from behind glass for a more interactive experience.

 I also wanted to capture more of the character and the attributes of the chickens: having five of them in a row allowed me to capture a variety of the different positions they get into and use a number of different techniques to explore their texture, such as needle felting, crochet and couching with wool fibres.

 Backing the piece onto some reclaimed wood adds to the texture, giving a more natural and rustic feel to the artwork – I have had many an admirer of this piece, imagining it hung up in their kitchen.

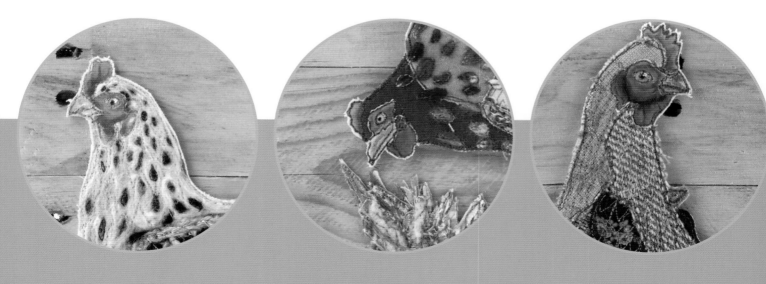

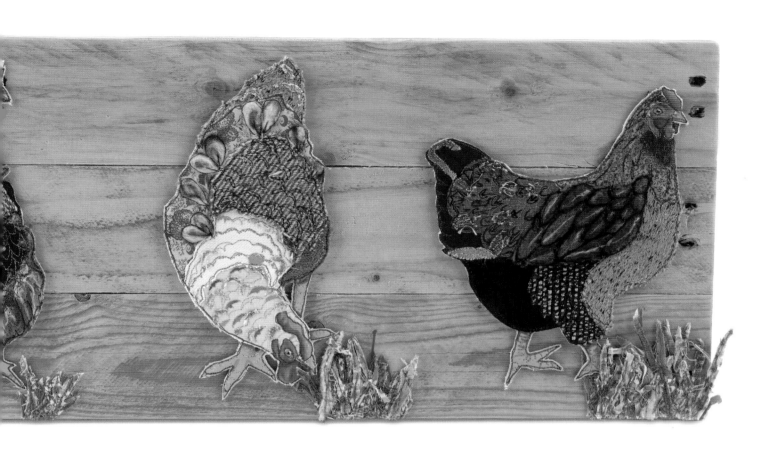

Collage

My collaging adventures started when I inherited my Grandma's sewing box. Filled with many gorgeous items I would never normally use, such as carpet darning thread, I was determined to find a way to incorporate them and their stunning vintage packaging in my work; to display them in an artistic way rather than leaving them inside the sewing box, unused and unloved.

This started a creative journey of using found items within my pieces and I have enjoyed every moment of it. It has definitely added a new lease of life and intrigue to my work.

Collaging ideas

I love collage; it offers a chance to be even more free and creative with the design of a piece than with fabric alone. You can have great fun combining elements that are both beautiful to look at and also have sentimental value.

Experimenting is key when collaging. Experiment with the placement of items, and combine using flat and three-dimensional elements. You can try collaging with fabrics, lace, doilies, buttons, vintage packaging, small pieces of crochet, knitting or tatting, tiny elements of ceramics, wire, wool, driftwood, book pages, music sheets and so much more – almost anything can be used within your textile collages. Your imagination is your only limit!

Items can be collected from all over: from family and friends, or charity, vintage and haberdashery shops. They can be picked up on beaches and anywhere else something interesting and beautiful catches your eye.

It can be challenging to incorporate some items, so I often work with collage like a jigsaw puzzle, moving items around until they sit perfectly on top of a background layer. Once that is right, I can then enjoy spending time building a top layer of more three-dimensional items.

Found items and collaging can be incorporated within your pieces in many different ways. You might include just a small item here or there, or you might make your whole piece into a little scrapbook, bringing together a series of disparate elements into one glorious artwork.

Work from your background fabric towards the front, layer by layer. When you are positioning your items, make sure you keep the rule of thirds in mind, using the gridlines to aid your placement of your points of interest to help you create a visually strong and striking image. This way of working and building a piece is more organic and fluid than working from an already thought-out and preconceived design; so please have fun with the process and allow it to tap into another area of your budding creativity and enjoy the freedom.

Opposite:
Fox Collage
A rustic, natural–feeling piece, with colours inspired by nature and the fox himself.

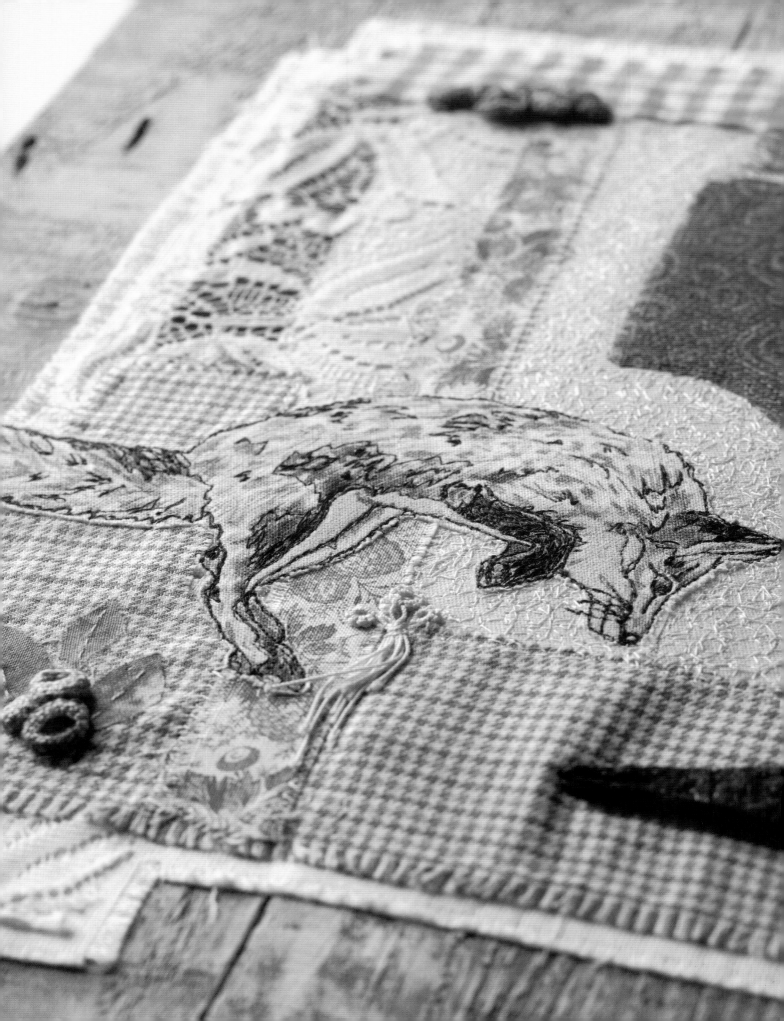

Re-use

I love using discarded or forgotten items in new pieces that will be loved and admired. A great deal of thought clearly went into the making of these vintage items, with even the packaging being quite beautiful. I enjoy using collages to celebrate that.

Of course, that's not to say that all innovation is bad. Combining the vintage items with the vibrancy and variety of newer materials is also a part of displaying the items at their best, so combine your older found items and fabrics with newer fabrics and ribbons, to set both off.

Be careful not to overcrowd a collage with old materials and bits. Instead, pick a few select items and display them on a background that shows them to their best, to avoid distracting and detracting from them.

Cutting out smaller pieces of old work and placing them within a collage is also a great way to recycle work that hasn't seen the light of day in a while – sometimes it is the perfect addition to a new piece.

Belt buckle
This old belt buckle was inherited from my Grandma, a throwback to the time when no item from old clothing went to waste. It was collected and stored, ready to have another lease of life at a later date.

Surprising choices
Combining unconventional items such as this carpet thread and threaded needles helps to give the collage more of a theme. Note the use of an odd number of items.

Opposite:
Fond Memories
This collage was cut out and mounted onto a reclaimed wooden background, continuing with the theme of recycling and giving old items a new lease of life.

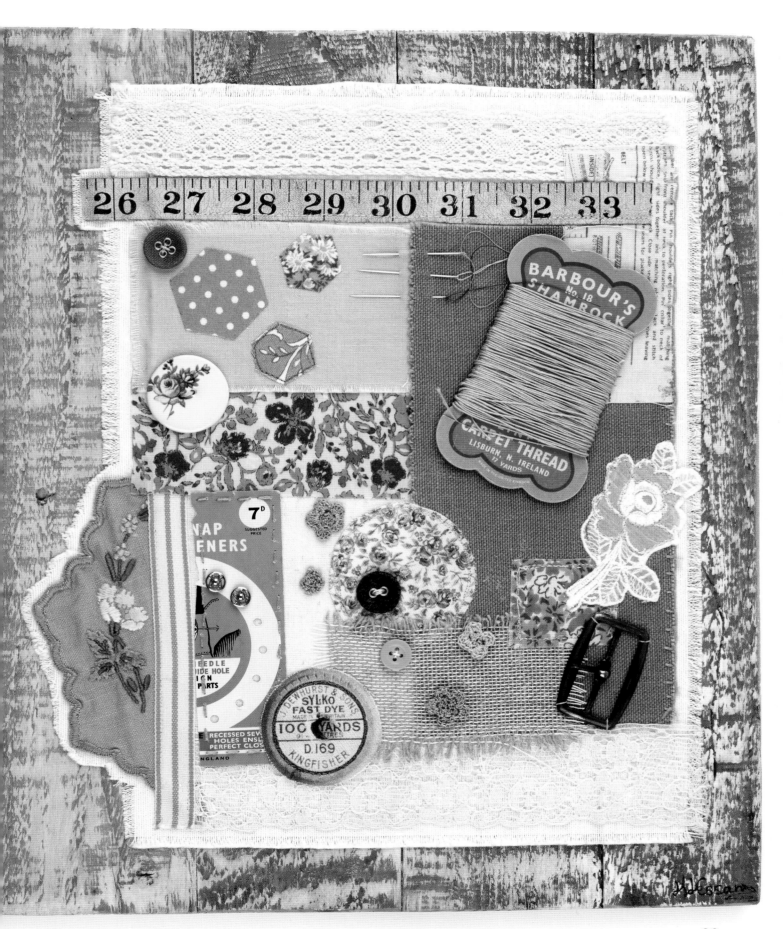

Sewing Collage

This project introduces far more choice than the earlier ones, and is intended to allow you to practise your collage and compositional skills. Before you begin, decide on your background fabric or fabrics, and collect the found items you would like to incorporate. When picking your fabrics, mixing some modern materials with your vintage items can give your piece a twist.

Unlike the projects earlier in the book, which use a single large image as the focus, the design elements here are stitched individually, then combined with found objects and built up into an exciting collage.

The underlying techniques are similar to previous projects, so feel free to refer to earlier in the book if you want clarification on a particular technique.

When selecting your background fabrics, I recommend having one that covers the whole of the embroidery hoop to form a stable base, then you can bring in other materials on top for detail and colour.

The finished piece can be hung with a nail under the tightening screw, or you could mount the piece on a circular piece of reclaimed wood or something similar if you prefer.

YOU WILL NEED

Equipment:
Sewing machine, embroidery foot, needle, bobbin
Iron and ironing board
Ballpoint pen
Large and small fabric and paper scissors
Sticky tape
Hand sewing needle
Camera or smartphone
Double-sided sticky tape
Gluestick
Fabric glue and brush
Embroidery hoop – approximately 30cm (11¾in)

Materials:
Medium weight calico or a similar weight piece of fabric for backing, at least 25 x 32cm (9¾ x 12½in)
Blue and beige linen for backing, at least 45 x 45cm (17¾ x 17¾in)
Appliqué fabrics
Pattern paper
Cartridge paper – 30 x 42cm (11¾ x 16½in)
Iron-on interfacing
Fusible webbing
Silk threads for hand embroidery
Machine threads
Found items such as vintage packaging, buttons, lace, tape measure; or anything you would like to incorporate

Opposite:
The finished piece

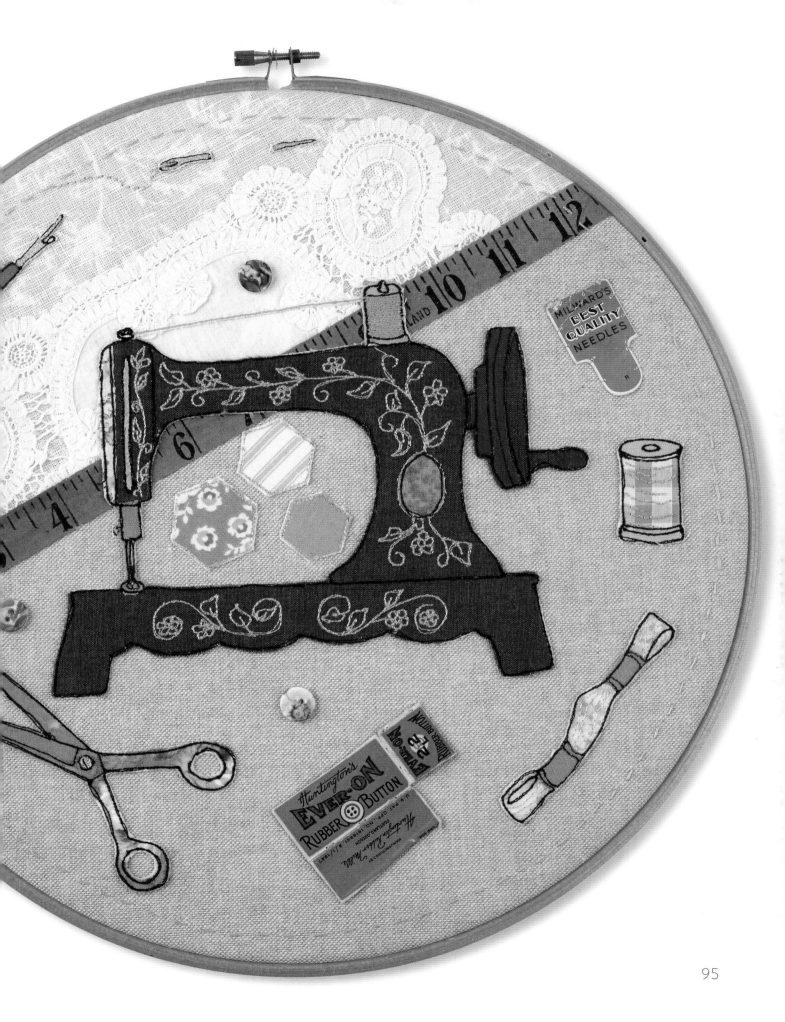

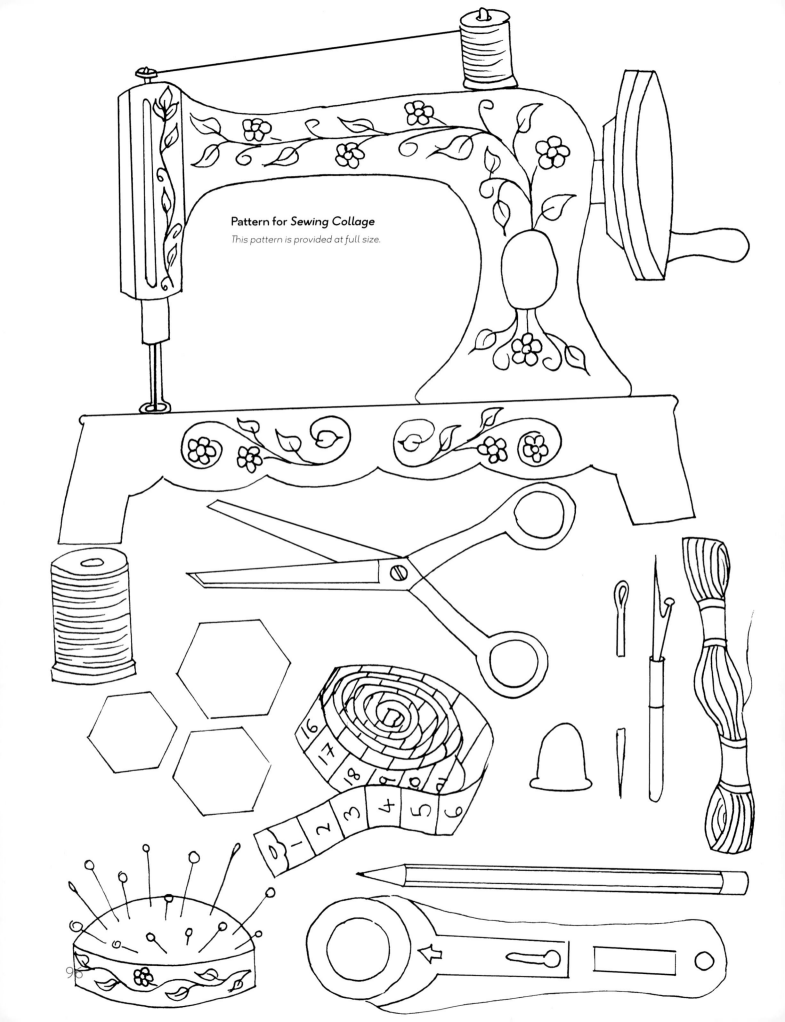

Pattern for *Sewing Collage*
This pattern is provided at full size.

Composing and planning the piece

The design pattern opposite shows a selection of pieces – you won't need them all; just pick your favourites. Before you start, take a large piece of cartridge paper and draw around the outside edge of your embroidery hoop. Mark where the top and tightening screw will be. This will form the design space.

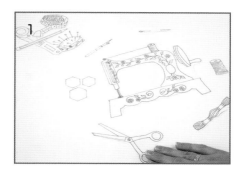

1 Trace and roughly cut out all designs pieces that you would like to use within your piece. Pick just a few – trying to use them all will make for a crowded, over-busy finish.

2 Arrange them on the paper, within the design space, along with your found items. Lay them down as you think they might work, then spend a little time moving and swapping them around until they are positioned as you would like. Consider whether you want to use different background fabrics and, if so, where you want them. When you are happy with the positioning, take a photograph to record the layout.

3 Use the photograph as reference to create a drawing of your final design. Start by marking out any large areas of different background fabrics. Next, place all of the paper design pieces and stick them in place using a gluestick or double-sided sticky tape. Finally, you can draw around the edge of each found item or just sketch in their placement.

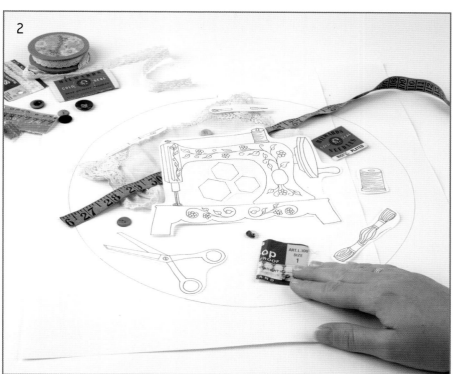

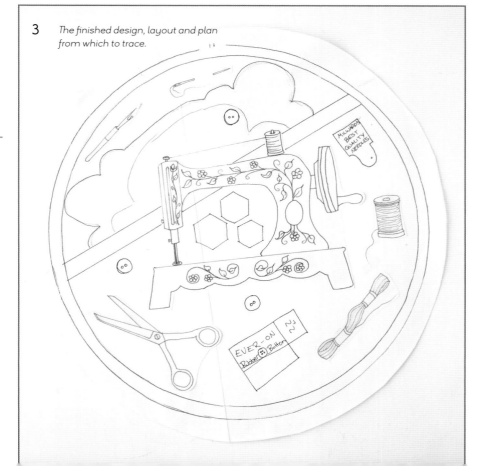

3 *The finished design, layout and plan from which to trace.*

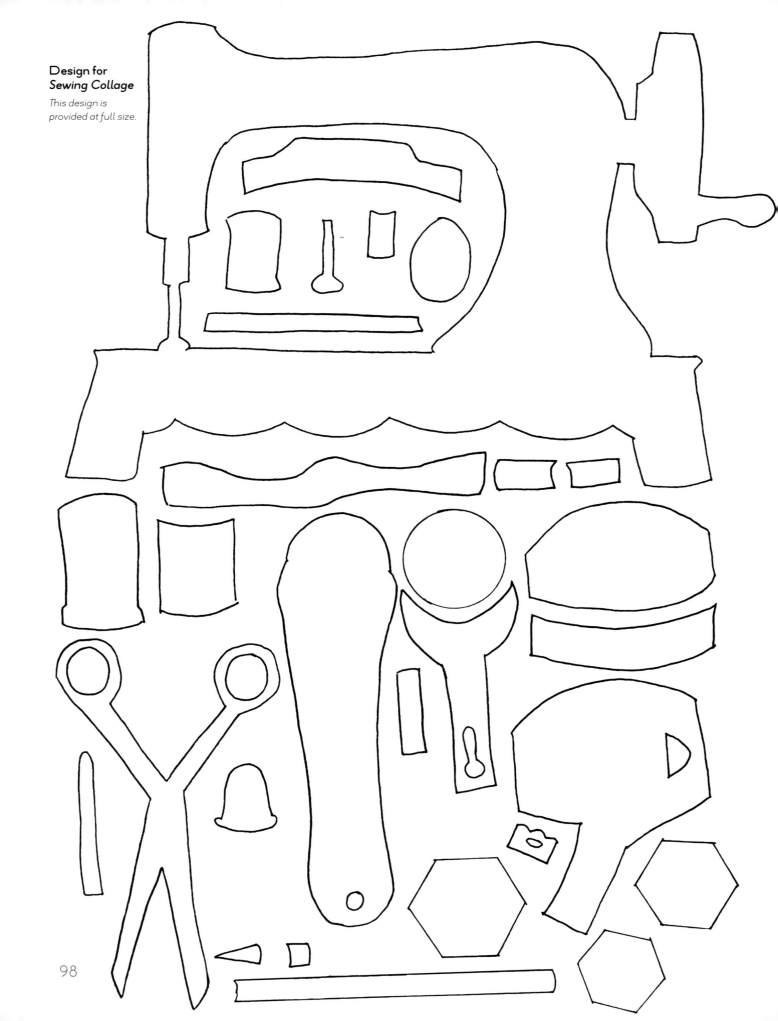

Creating the appliqué sewing paraphernalia

It is very important at this stage to get the templates, pieces and fusible webbing all the right way round, so pay particular attention to the facings of both the paper templates and the fusible webbing when tracing or ironing them on – you don't want to create a sticky mess later on!

TIP

Page 54 shows the technique of using the pattern paper to help place the pieces accurately, if you need a little revision.

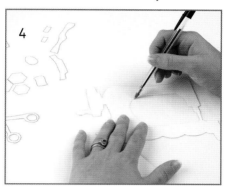

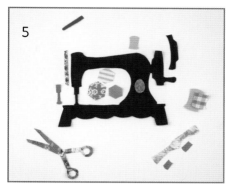

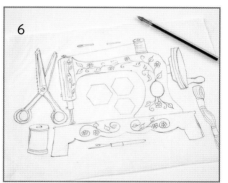

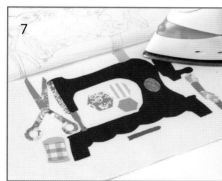

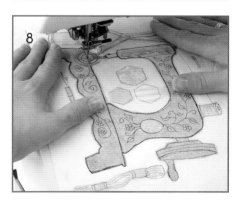

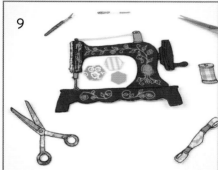

4 Make copies of the templates for the items and parts of items you are using from the design opposite, then cut them out. Working one by one, place each piece face-down on the paper side of the fusible webbing and trace round them.

5 Pick your fabrics for appliqué – ones that work with both your background materials and with the found items that you will be incorporating. Iron fusible webbing pieces on the wrong side of your fabric, then cut each piece out.

6 On a piece of pattern paper approximately 30 x 24cm (11¾ x 9½in) Create a pattern by tracing all of the pieces you are using from page 96, and detail them using the pattern for guidance. Group them as closely together as possible. Cut a piece of calico large enough that all your chosen design items will fit on it snugly.

7 Cut a piece of interfacing, a little smaller than the calico piece, and iron it onto the back of the calico. Pin the pattern to it at the top two corners. One by one, remove the paper backing from each appliqué piece and place it onto the calico, under the paper. Work from the background to the foreground (e.g. the body of the sewing machine first, then the details). Pin the bottom two corners down, then re-draw any pen lines that aren't in line with the edge of your appliqué fabric. Use the iron to secure the pieces in place.

8 Use the freehand machine embroidery technique to stitch round each of the pieces. Follow all the lines, and use a variety of coloured threads to match or complement the pieces. Remove all pattern paper and iron a piece of fusible webbing onto the back side of the calico, covering all the items stitched onto it.

9 Cut out all of the pieces, as closely to the stitching as you can, and put them safely to one side.

10 Cut a second piece of pattern paper to size, about 5cm (2in) larger than your embroidery hoop. Trace the full design and layout you made (see step 3), and make a mark at the top centre point of your hoop, where the tightening screw will be.

Creating the background

Your main backing piece should be large enough to cover the embroidery hoop entirely. Place your hoop on the back of your main background fabric, then draw another circle about 5–8cm (2–3in) larger than the embroidery hoop circle, to give you a margin and enough spare fabric to secure in the hoop. Similarly, cut any other background fabrics with an extra margin, past where they will meet the embroidery hoop.

TIP

When your layers of fabric are thicker, or there are more of them, your ironing time to adhere the fusible webbing will increase. Keep heat applied until it has fully adhered. You can even try ironing your piece from the reverse as well as from the front.

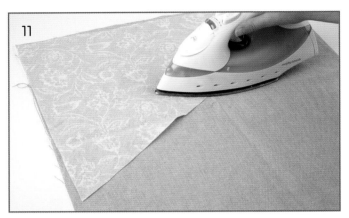

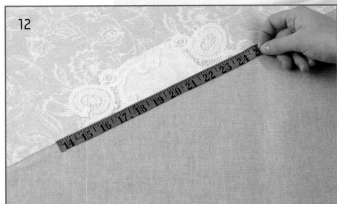

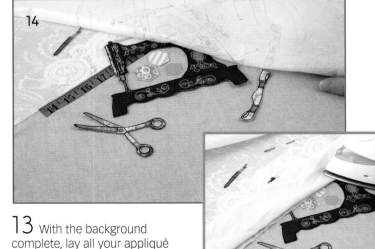

11 Cut a circle of interfacing about 2cm (¾in) larger than your embroidery hoop and iron it onto your main background fabric. Make a mark at the top of your background fabric to let you know where your centre point is (where the screw on the embroidery hoop will fall). Pin your pattern paper design in place, at the top two corners, making sure your two centre marks line up. This will show you where to place both the appliqué pieces and other collage items. If you decide to layer more than one background fabric (as in my example), use a layer of heat-fusible webbing to attach smaller pieces to the main backing fabric.

12 Working from the back of the design to the front, attach all the background items: use fusible webbing to attach any pieces of lace or other materials that you wish to incorporate. For found items that cannot be ironed, like the tape measure, pin the item in place temporarily, placing the pins where you won't be ironing over appliqué pieces or stitching later.

13 With the background complete, lay all your appliqué pieces in position with your pattern paper design on top to check that everything looks right.

14 Peel off fusible webbing backing paper and iron each appliqué piece in place in turn. If you have used an item that cannot be ironed within your piece (such as this real tape measure), place a piece of fabric under the iron to insulate the item a little more from the heat (see inset).

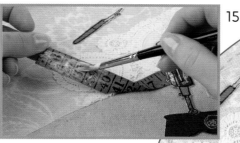

15

15 Attach your found items using either hand stitch (blanket stitch could make an interesting feature edging), fabric glue (see inset) or normal machine stitch. Hand sew on any buttons.

TIP

If stitching through card, especially with a machine, switch to a more heavy-duty needle.

16 Place the finished piece in th embroidery hoop, centred and pull taut. For an optional added detail, you can add an extra line of running stitch by hand, about 1.5cm (½in) from the edge of the embroidery hoop, as shown here.

17 Turn the piece over. Leaving about a 5cm (2in) margin, cut the excess fabric away from the edge of the embroidery hoop. Take a length of doubled embroidery thread long enough to stitch around the whole embroidery hoop, and work running stitch around the edge of the circle of fabric just outside the hoop, about 1cm (½in) from the edge. Pull the thread taut, so that the fabric gathers tightly on the back side of the embroidery hoop. Finish off the stitching with a number of small tight stitches, then trim the thread.

18 Cut yourself a circle of fabric – felt works well – just a little smaller than the embroidery hoop. Pin it in place on the back side of the hoop, so the fabric is taut, then hand-stitch it in place using a diagonal running stitch.

16

17

18

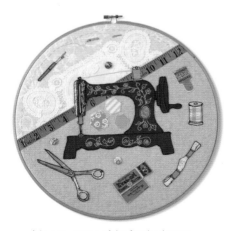

A larger version of the finished piece can be seen on page 95.

Sew Lovely

For this piece I wanted to suggest more of a collage feel within my design. Inspired by sewing and all the tools that I and other sewers use every day, I made this piece as an ode to sewers everywhere and topped it off by mounting it in an embroidery hoop. It has become one of my most popular pieces with my clients.

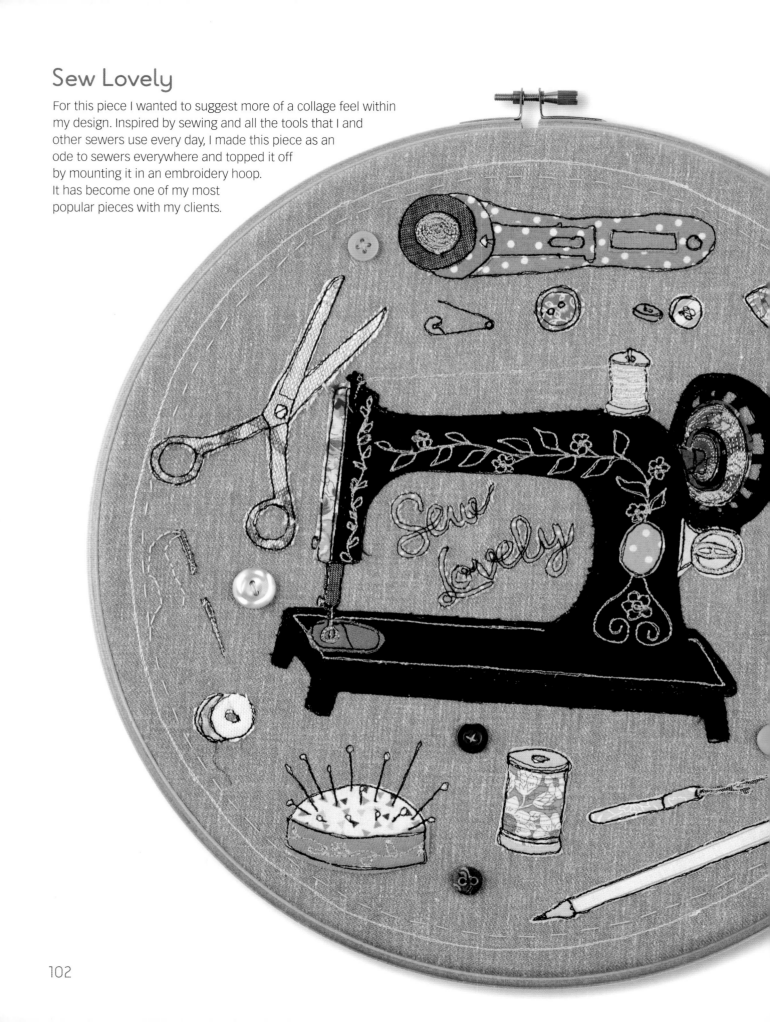

Rotary cutter

An intense area of stitching in the centre of the cutter is used here instead of another layer of appliqué.

Tape measure

The numbers were drawn in with a ballpoint pen after the stitching was complete and the pattern paper removed. This achieves a neater and gentler effect on the tape measure.

Sewing machine decoration

Some metallic stitched detail, just like on a real vintage Singer sewing machine. The gold detailing on a dark plain fabric is beautiful and eye-catching.

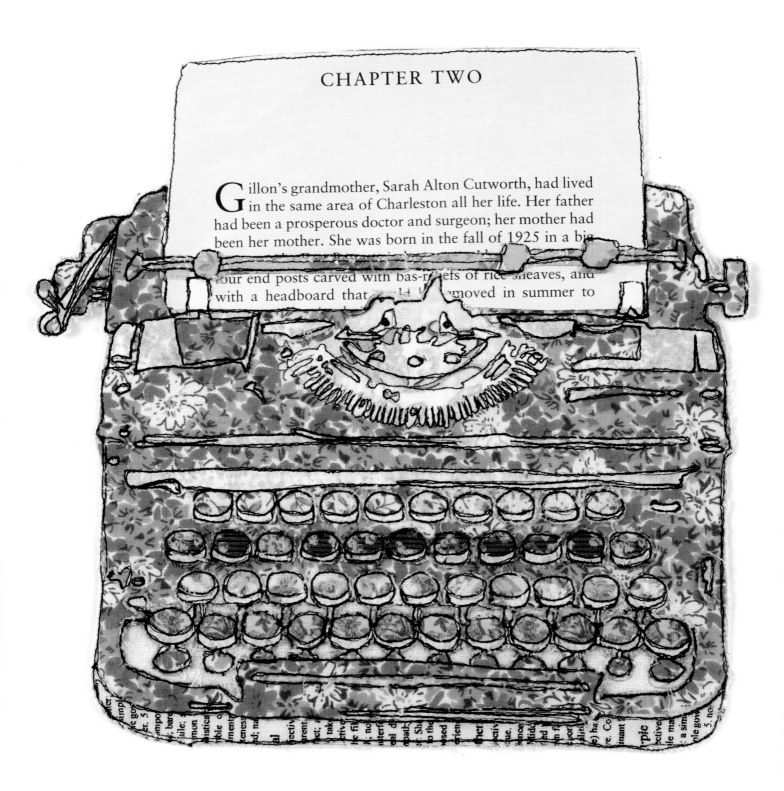

CHAPTER TWO

Gillon's grandmother, Sarah Alton Cutworth, had lived in the same area of Charleston all her life. Her father had been a prosperous doctor and surgeon; her mother had been her mother. She was born in the fall of 1925 in a big ... four end posts carved with bas-reliefs of rice sheaves, and with a headboard that ... removed in summer to ...

Typewriter

I am a huge lover of all things vintage – their quirky, intricate character and the story they have to tell is just intoxicating. Capturing the typewriter in fabric and stitch form was a lot of fun. It pushed me technically to incorporate found items, as well as different types of appliqué, in order to get the best from the subject matter.

The text

A real book page has been incorporated within this piece to give the illusion of a typed document in the typewriter. It adds a lovely contrast with the texture of the surrounding fabric.

Keyboard

For the rows of many tiny keys, I have used a long thin strip of fabric, stitched the keys and then cut away the excess fabric around and in between them. This is a more effective way of using appliqué – cut appliqué, in this example.

Typebars

Pattern paper has been left on the piece beneath the typebars here to make it stand out against the patterned fabric below.

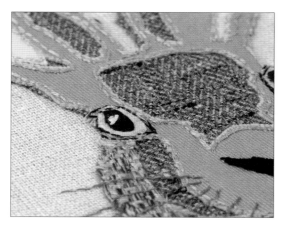

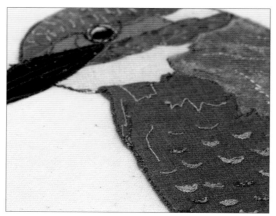

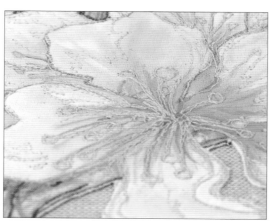

Choosing your own design

The beauty of textile art is that it lends itself well to the creation of any subject matter, whether you are looking at a scene from nature, everyday life or anything else that inspires you.

This part of the book looks into the different creative avenues available to you when creating your own textile art.

Creating the design

Translating a visual image – such as a photograph, sketch or a scene in front of you – into a design can be done by making a line drawing, either by tracing or sketching.

It is best to simplify the image you wish to work from, especially if you are working from a photograph. You will want to incorporate important details and texture lines, but leave out any excess details that won't add to your piece as including these could end up distracting from the piece.

When tracing your image, you will need the main outline, and any important structural details (such as eyes, beaks, doors, roofs and similar parts). You will also want to include certain details that you want to emphasize, such as feathers, flower veins, tide lines or ripples. Be selective with these details. Choose just enough to capture your subject, but not so many that it makes the piece look too crowded or messy.

Once you have completed your simplified sketch, you need to choose your techniques. A simple piece might focus solely on freehand machine embroidery – the beach scene project on pages 27–33 is a good example – or you might choose to incorporate additional techniques.

Which techniques to use?

The projects earlier in the book all use free machine embroidery in combination with one or more other techniques. The hare, for example, uses freehand machine embroidery and appliqué; while the chickens incorporate freehand machine embroidery, appliqué, paint and texture. Part of the beauty of creating your own design is that you can use any techniques or combination of techniques that particularly appeal to you.

When starting out, it is an interesting exercise to create the same image using different techniques to see the effects that can be achieved with different combinations. This may result in you finding a particular technique or combination that you prefer to use. See pages 108 and 117 for two variations on the same image that use different techniques.

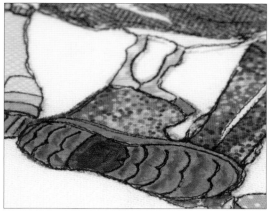

Templates

When you use appliqué, your image not only needs to be simplified into a sketch, but also broken down into templates: deconstructed into constituent parts. For example, the chickens on page 76 are broken down into heads, bodies, wings and so forth.

I always find it best to have a base layer that covers the whole of the subject matter and then ones that layer up on top, as this makes sure you have neat joins and no background fabric peeking through in between your appliqué pieces.

Practice makes perfect

The projects on the following pages are designed to show how to choose and interpret your own chosen image. One project shows you how to use a design to translate a piece into paint and freehand machine embroidery and the other one how to translate your design into appliqué and freehand machine embroidery.

Each project will take you through the steps you will need to apply to your own choice of image depending on which combination of techniques you wish to use.

Please use these projects and steps as a guide to help you produce your own textile artworks, and feel free to vary the combinations of techniques as you get more familiar with the process.

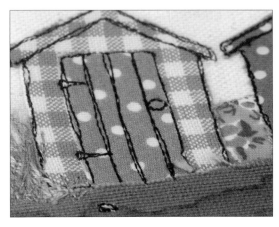

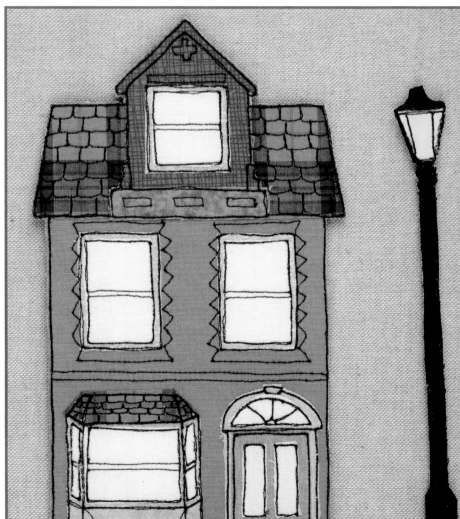

Jimmy the Cat

This project will show you how to take a photograph and interpret it using freehand machine embroidery and paint.

We start by translating a photograph of a cat into a line drawing, picking out the details and texture we want to include in the piece. This then becomes the design you work from. The design is then transferred onto fabric to be painted and then stitched.

Once you have worked through this technique, you will be able to translate your own photograph into a simple line drawing and then turn it into a painted and stitched textile art piece.

YOU WILL NEED

Equipment:
Sewing machine, embroidery foot, needle, bobbin
Iron and ironing board
Ballpoint pen
Large and small fabric and paper scissors
Sticky tape
Computer and printer
Paintbrushes
Water pot
Paint palette
Kitchen paper
Light box or window

Materials:
Medium weight calico or a similar weight piece of fabric for backing
Blue linen
Pattern paper
Cartridge paper – 21 x 30cm (8¼ x 11¾in)
Iron-on interfacing
Fusible webbing
Machine threads
Acrylic paints: browns, pinks, yellows and white

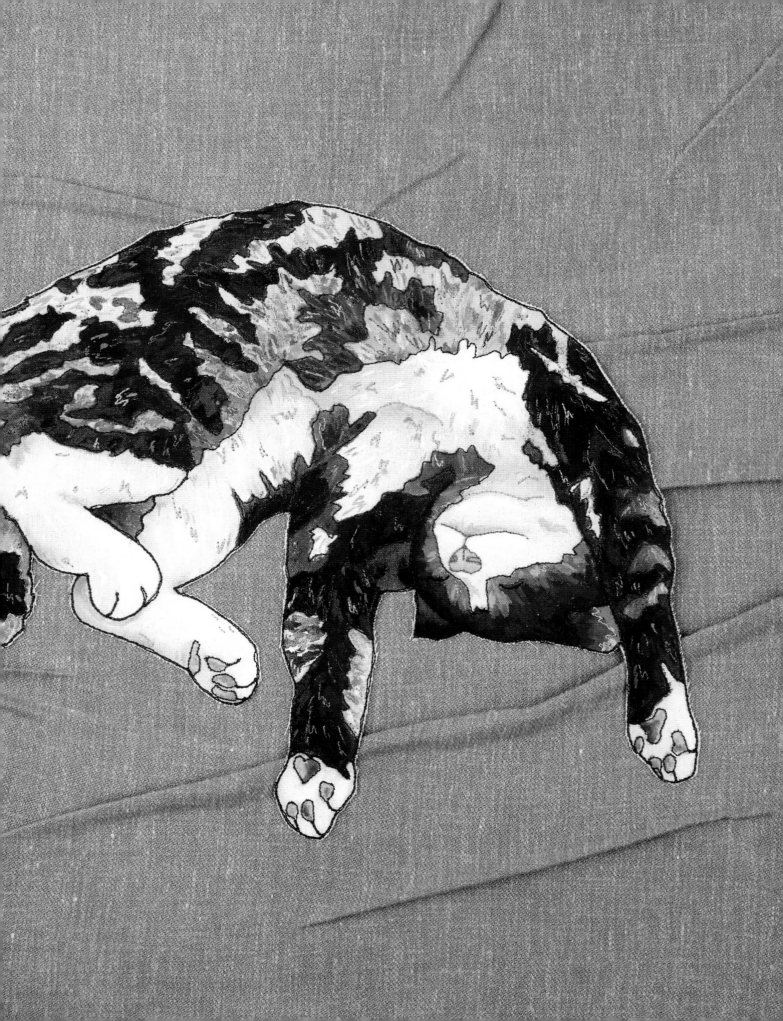

Working from a photograph

Photographs can appear quite complex. This technique simplifies the image to make it more suited to the free machine embroidery technique, and gives you a chance to experiment with the design. If the image you have selected is already a simple line sketch you could use this exercise to edit the design slightly, leaving some items out, adding some in or moving objects to make your piece work for you.

Before you start, print out a colour copy of the image you wish to create in textile art form. This should be fairly large in size, but be careful that it does not become pixellated or reduced in quality. I tend to print the image at A4 size – that is, 21 x 29cm (8¼ x 11¾in). Tracing the image on a lightbox makes this job much easier and ensures that the lines will be clean and good quality. If you do not have one, you can simply hold the paper up to a brightly lit window.

When taking a photograph that you intend to use for your textile art, make sure that the picture includes all the information you need – a blurry or tiny detail in a photograph is much harder to translate than a large, clear image.

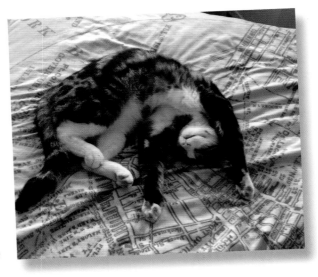

I was drawn to this image because of the cat's position; I love how it portrays the character of the cat. The folds in the bedding also give another great opportunity to add texture into the piece. The picture was taken by an old friend of mine, of her lovely boy Jimmy.

1 Use a ballpoint pen to draw lines on top of the image, establishing the outline and picking out details such as edges of objects, fur direction, colour changes and areas of highlight or shadow. Be careful not to leave out any details that you want in your piece.

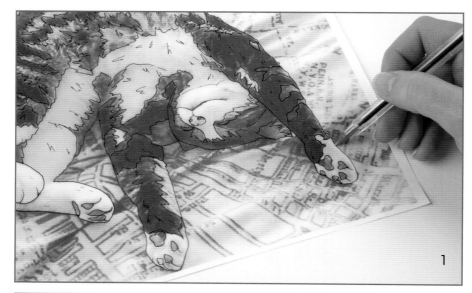

2 Place the image on top of your lightbox, then lay a plain piece of paper on top. Use the ballpoint pen to trace the lines you have just drawn on the image through to the paper to create your basic initial design.

3 Take the paper off the light box and check that you have transferred all the lines. Make any adjustments or corrections that you need to.

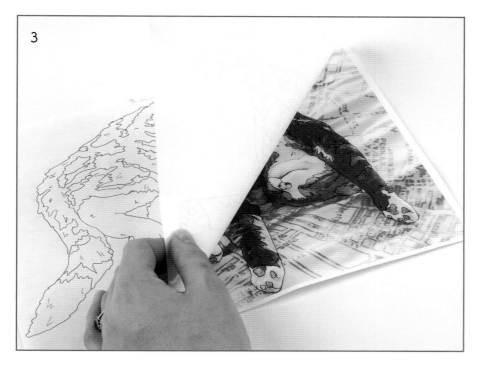

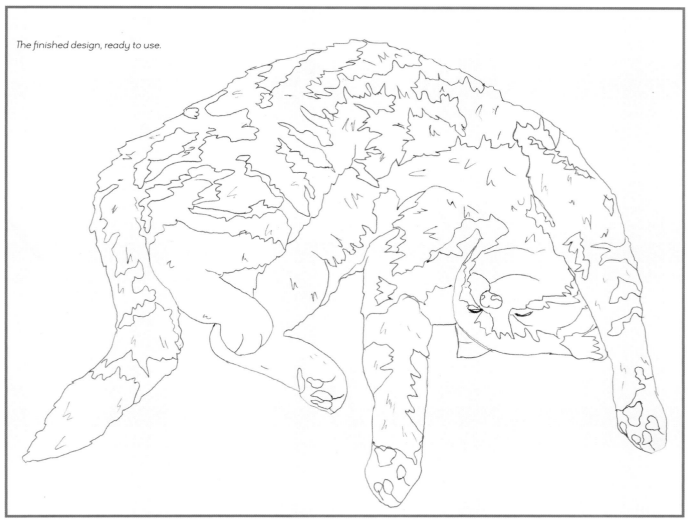

The finished design, ready to use.

Painting

I have used acrylic paints in this example; however you can use watercolour paints instead.

4 Cut yourself a piece of calico at the same size as your design (21 x 29cm (8¼ x 11¾in), plus a margin of about 8cm (3in). Cut a piece of iron-on interfacing just a little smaller than your calico piece, but don't iron it onto the back just yet. Lay the calico on top of your line drawing so the design is in the centre of the fabric, then secure it in place with a small piece of sticky tape. Trace all your lines through on to the calico using a black ballpoint pen.

5 Your image is ready to paint. Prepare your paints. For this project, you will need a variety of browns, creams and pinks (the latter for the paws and nose).

6 Start painting the first layer with background colours. You may find it helpful to refer to the original photograph if possible, or your copy.

7 Work over the whole design to paint in the first layer.

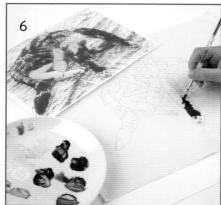

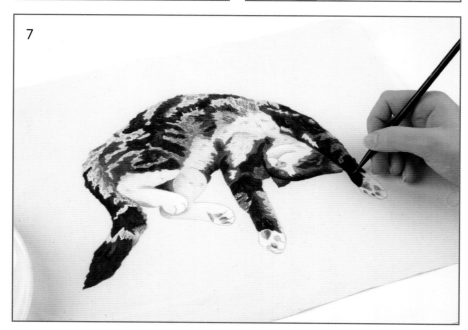

8 Once the first layer of paint is dry, paint the second layer, adding in the details. Fur marks, direction, highlights, lowlights, light flecks – this makes the piece look more alive, more realistic and more textured.

TIP

The eyes of this contented cat are shut, but if you need to paint open eyes, make sure to add in white flecks of reflected light, as they add life to the animal.

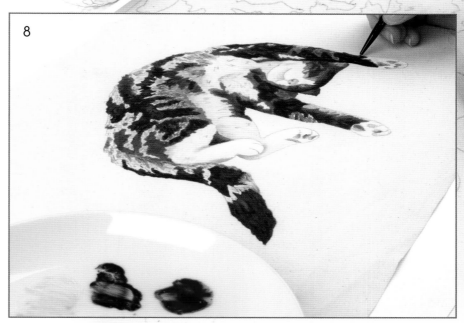

Details of the highlights and shadows.

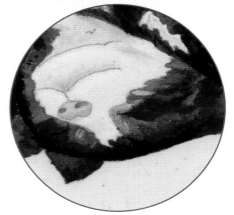

Details of the light flecks around the eyes.

9 When all the paint is dry, secure the layer of iron-on interfacing to the back of your painted image with an iron.

10 Choose a range of complementary thread colours, making sure you have some darker and some lighter than the paint colours you have used within the piece so far.

11 Starting somewhere inconspicuous, start to freehand machine embroider the main outline of subject and any main details in one colour.

12 Stitch in all the details using a variety of coloured threads, adding all the fur lines, adding texture and life.

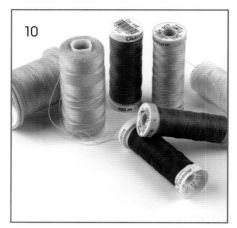

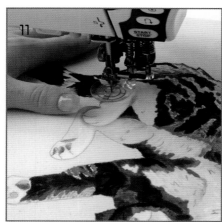

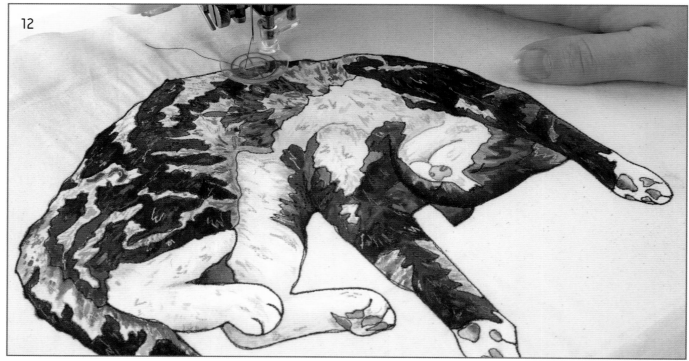

13 When all your stitching is complete, iron a layer of fusible webbing on the back side of the piece covering the whole design.

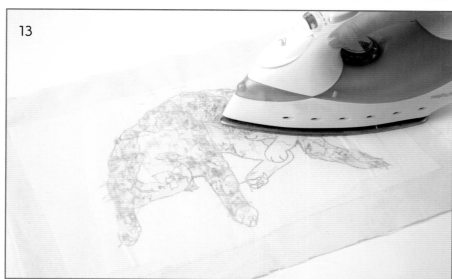

14 Cut out the cat with a pair of small fabric scissors, working close to the line but not cutting into the stitched lines.

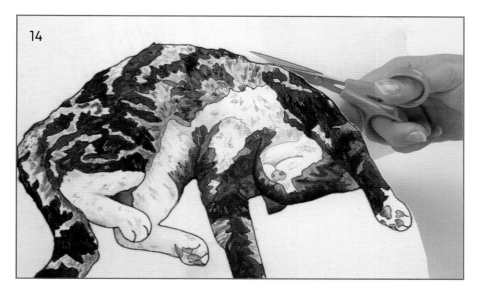

15 Re-mount the cat onto a final piece of backing fabric – I have used blue linen, which I pleated slightly before placing the cat on to it. As the fabric creases will be held in place, this gives the impression that the cat is actually on the bed sheets. Use a piece of scrap fabric between the iron and painted image to protect the paint work.

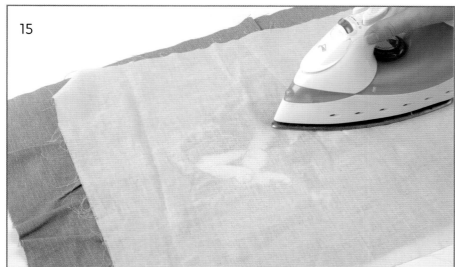

A larger version of the finished piece can be seen on pages 108–109.

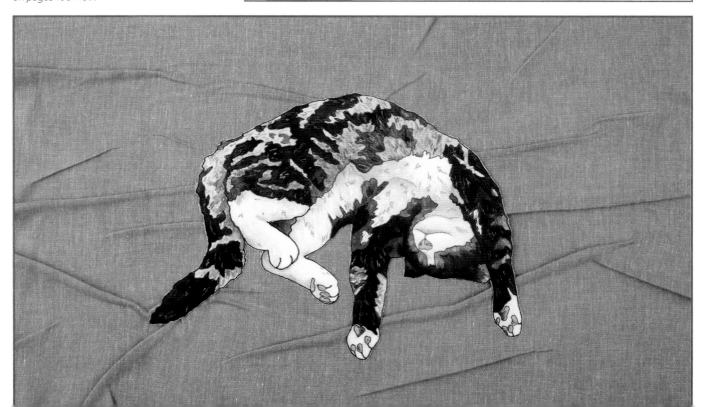

Fur on back

Lots of zigzag fur lines, in a number of different coloured threads, were built up over the piece to capture the texture of the cat's fur. Note that they suggest the direction in which the fur lies.

Paws

In comparison with the project on the previous pages, I have aimed for a simplified, more graphic result here, and concentrated purely on the outlines in these details. The paws could be painted with a pink pad for a splash of colour and a more lifelike result.

Tail

The tail incorporates a number of different appliqué layers, which help to show the colour gradation of the cat's fur.

Appliqué cat

This piece is made using the same image and design as the previous cat, but using five to ten pieces of appliqué and free machine embroidery rather than paint and free machine embroidery. It serves to demonstrate just how different the same image can look depending on the techniques you choose to make it with.

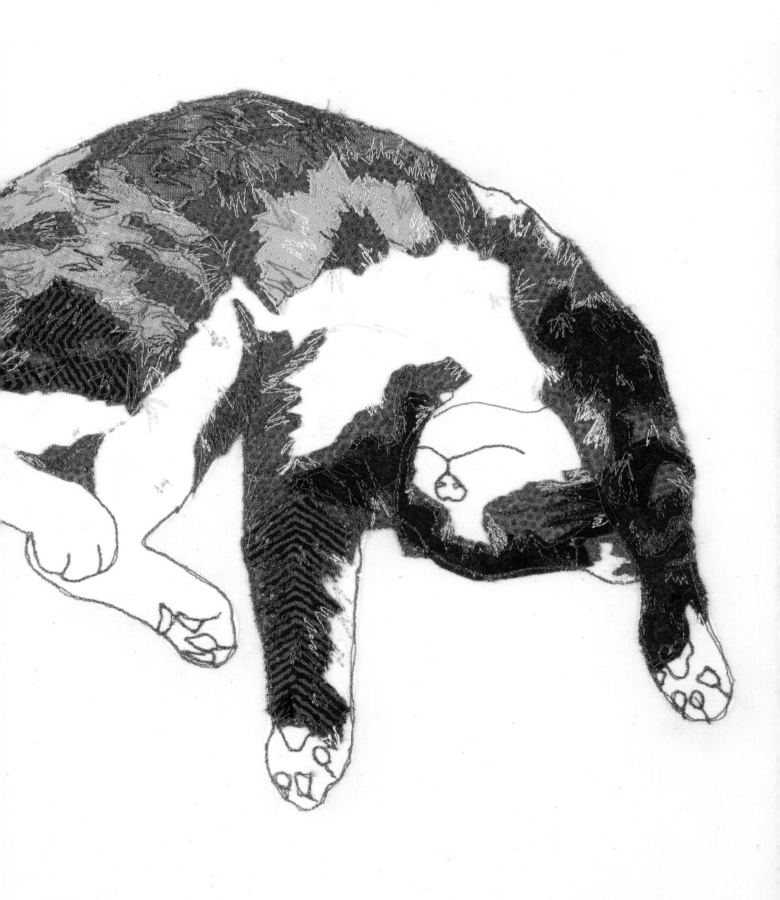

Home

This project shows you have to deconstruct an image from a sketch, and how to 'cut up' your image to make templates for each individual piece of appliqué that you would like. When planning your appliqué, you may wish to start fairly simply, with perhaps five to ten different pieces that make two to three layers. As you get the hang of the process, please get more adventurous and have fun!

The more appliqué pieces you wish to include, the more templates you need. In turn, this means you will need more copies printed of your design to cut up into your templates. When cutting them out, it's best to leave each template whole, without anything cut away from the inside of the template to keep the template sturdy. This will give you the best outcome when using it.

You will notice I use one piece of appliqué to cover the majority of my subject matter – the body of the house – and then layer the details on top. If you work in this way, you will find it easier to build up your appliqué layers and will achieve a neater finish. The other way in which this can be achieved is to overlap some of the appliqué layer. Making the bottom layer slightly larger allows the top layer to sit neatly on top with no visible joins. As an example, the house body piece in this project is made slightly taller so the roof will overlap for a perfect join.

YOU WILL NEED

Equipment:
Sewing machine, embroidery foot, needle, bobbin
Iron and ironing board
Ballpoint pen
Large and small fabric and paper scissors
Sticky tape
Computer, scanner and printer/photocopier
Fabric glue

Materials:
Medium weight calico or a similar weight piece of fabric for backing, at least 30 x 40cm (11¾ x 15¾in)
Linen for remounting, at least 32 x 42cm (12½ x 16½in)
Appliqué fabrics
Pattern paper
Cartridge paper – 21 x 30cm (8¼ x 11¾in)
Iron-on interfacing
Fusible webbing
Machine threads

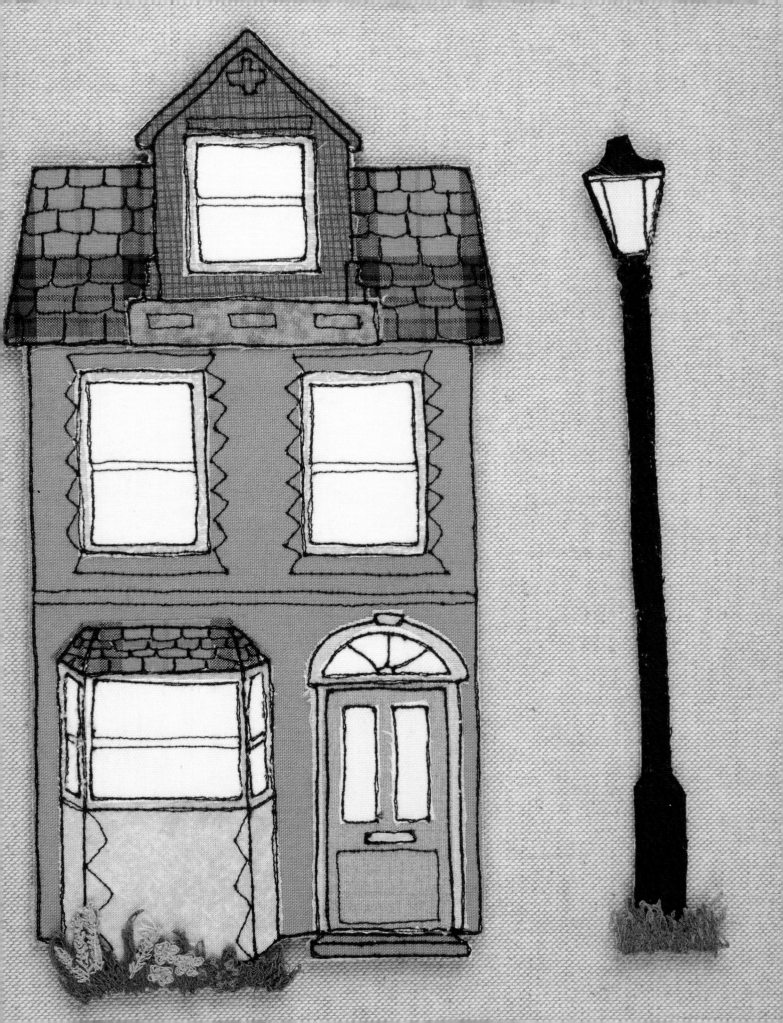

Pattern for _Home_

This pattern is provided at full size.

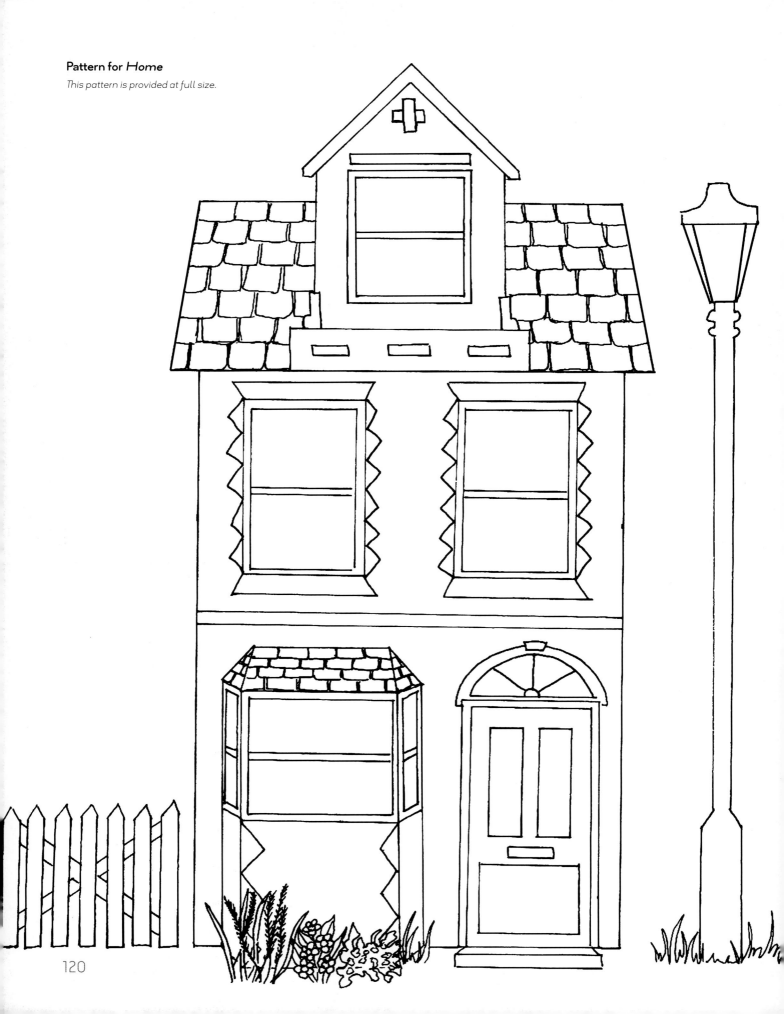

Deconstructing your image into templates

You need one template for each part of the image that you would like to be made of a different type of fabric.

For example, if I want the window frames to be in a purple fabric, that will require one template. If I want the window panes to be in a white fabric, that will require a second template.

1 Start by drawing out your image using a black ballpoint pen, picking out details and edges of objects carefully. Be careful not to leave out any details you want to retain in your piece. If you want to use the house, you can simply copy or trace the pattern opposite.

2 Use a scanner or photocopier to make five copies of your sketched image. The original image will be used to trace the pattern from, so leave it intact. Cut up the other copies into the component parts (see expanded image below) using your paper scissors. Cut closely to the lines.

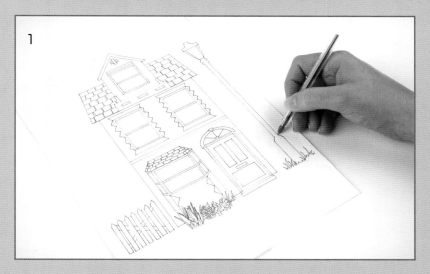

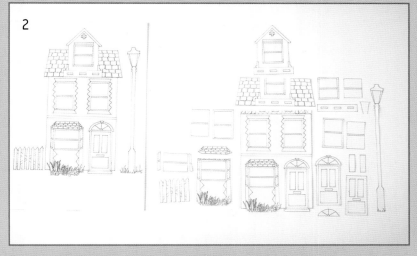

TIP

If you don't have access to a copier or scanner, you can trace your image onto multiple separate sheets of cartridge paper and then cut them into all the templates you need.

This picture shows the parts you will need in more detail. The numbers show which copy each piece was cut from, and the letters show the order in which they should be applied. Not every part of the five copies is used – for the upper layers, only a few select pieces are used. Note also that it is just the outlines that are important – you can ignore the details on pieces that will be covered by later layers.

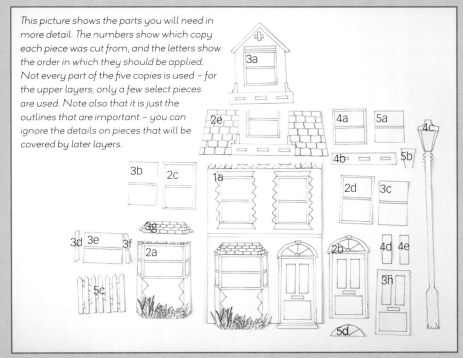

TIP

To avoid gaps in the finished piece, leave a little extra at the top of the main house in layer 1, and at the top of the bay window when cutting them out. Mark the areas with small crosses to remind you of the overlap.

Making the piece

3 Lay your fusible web paper (smooth) side up. Working one by one, place each template face-down onto the fusible web and carefully draw around with a ballpoint pen. Roughly cut out each fusible web piece, leaving a small margin around the edge. Pick your appliqué fabrics. Iron your fusible web piece onto the back of the relevant fabric piece – rough (glue) side fabric down toward the fabric. Roughly cut all fusible web away from larger fabric pieces, then trim closer; just to the outside of your lines, with a tiny margin.

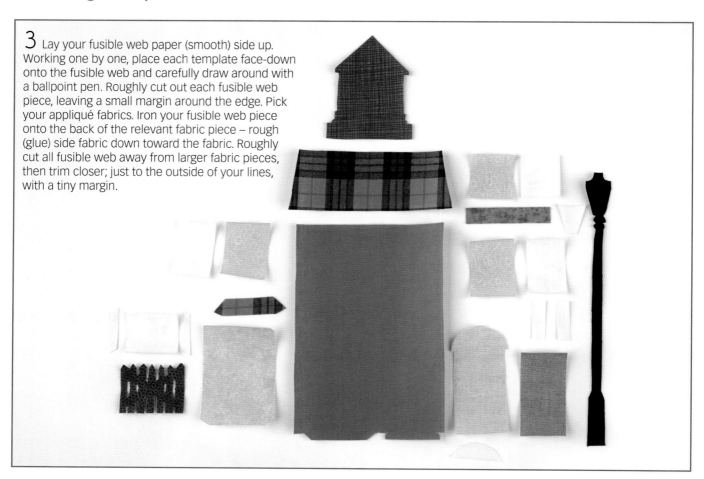

4 Roughly cut the backing fabric to size, including an 8cm (3in) margin. Cut a piece of interfacing a little smaller than this, and iron it in place on the back side of the backing fabric.

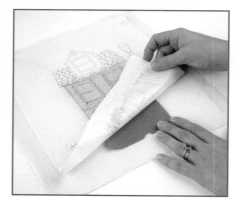

5 Cut a piece of pattern paper large enough to cover the image and trace the design onto it using a black ballpoint pen. Pin the top two corners of the pattern paper onto backing fabric, then begin placing the pieces, starting with the main house piece from layer 1.

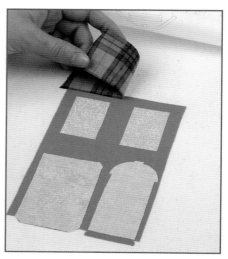

6 Remove the paper backing from the webbing and iron the main house piece in place. Next, add the pieces from layer 2, securing them in the correct order, working one at a time from the back to the front. Overlap the roof as shown.

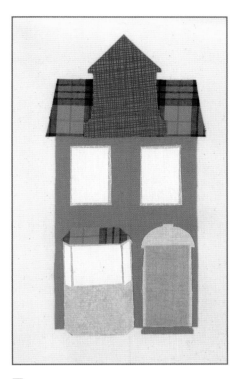

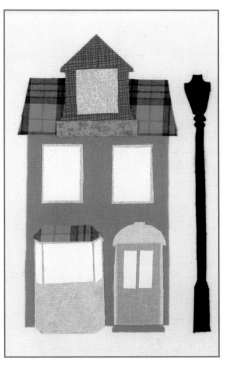

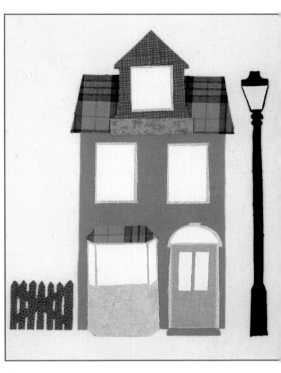

7 Repeat for the pieces from layer 3, being careful to overlap the top of the bay window with the roof (part 3g).

8 Still working one at a time, place and secure the parts from layer 4.

9 Add the final parts from layer 5.

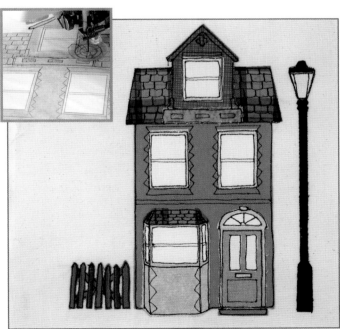

10 Lay the pattern paper over the complete appliqué design, pin the bottom two corner and, if necessary, use a ballpoint pen to redraw any lines on your pattern. Remember to cross out any old lines to make things clear.

11 Set up your machine and begin free machine embroidering around the outlines of the pieces (see inset). Freehand machine embroider all your lines twice. When all stitching is complete, remove all pattern paper. Iron on a layer of fusible webbing on to the back side of your work, covering the whole design.

12 Cut out the house, fence and lamppost separately, cutting close to the stitched lines. This is now ready to be remounted. The finished piece can be seen on pages 118–119.

Suburban Life

This piece was a technical challenge for me. I wanted to piece to be more interactive, out from behind glass, a fun representation of suburban life – but how could I make the piece three-dimensional and mount it without placing it into a large, deep box frame?

The answer was to use a shelf to serve as the basis, then to build the piece on top of it. I am really pleased with the way the piece came together, combining reclaimed wood, fabric thread, paint, wire and found items.

House fabrics

The fabrics for this piece were not picked to be normal or realistic house colours, but to give a full and bright colour palette that would work well together in a piece.

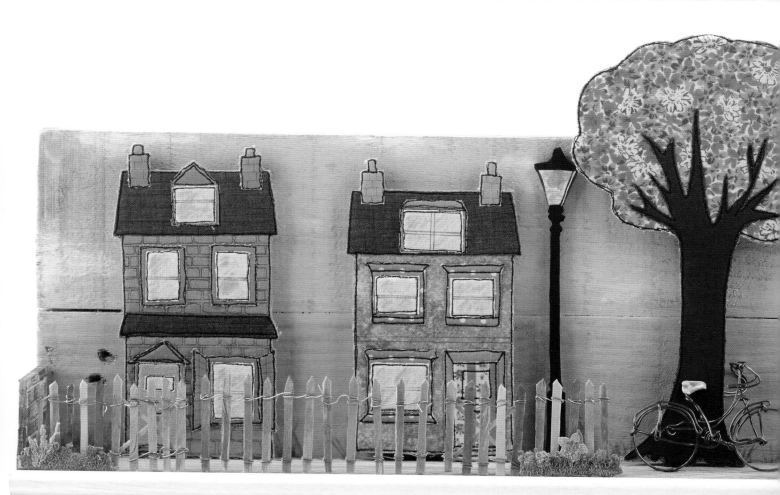

Tree

The tree was made to stand proud of the backing. 'Breaking the frame' like this helps to give an interesting and whimsical feel to the piece.

Postbox and fence

The little fence, made from coffee stirrers and wire, is set a little in front of the houses for a three-dimensional effect. It is adorned with little stitched flowers set at intervals along the fence for flashes of colour and intrigue.

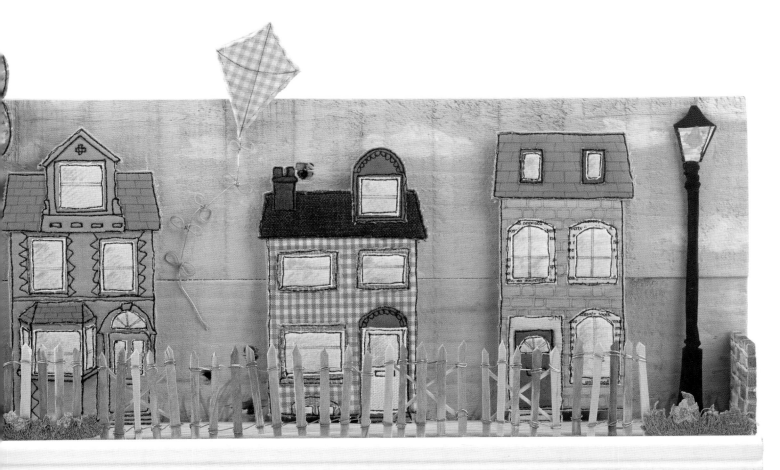

Displaying your work

Framing and finishing your piece is key to showing it off at its best and this can be done in a number of different ways. Shown are a few different suggestions for displaying – or wearing – your work.

Framing and mounting

If you want to frame a piece, it is usually best to make and fit your design to a pre-bought frame with a mount inside, rather than getting a frame made for your image, as this can work out to be quite pricey.

To attach your textile piece to the mount, use fabric glue and weight down the mount until the glue is completely dry. This normally takes around twelve hours. Neatly trim any excess fabric around the mount, leaving an approximately 2cm (¾in) surround, and secure that in place with either more fabric glue or masking tape.

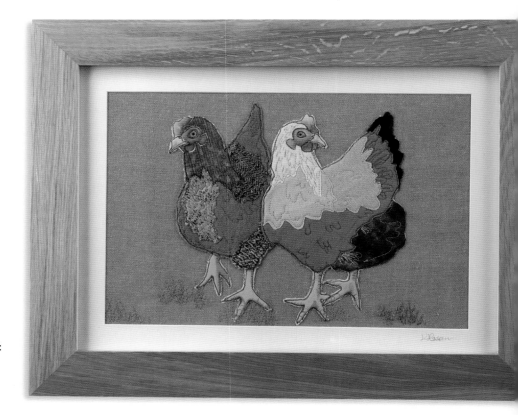

Wooden frame and white mount

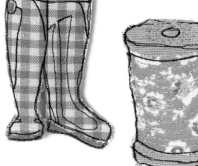

Wearable and functional pieces

Smaller items, like the life-size example to the left, can be used to make a brooch. If you wish to use an item in this way, I recommend using two layers of backing fabric behind to help stiffen the piece. When all of the appliqué and stitching is complete, cut out the item close to the stitched line and secure onto a brooch pin.

This technique can also be used if you would like to cut out your work and mount it on a bag or cushion for a functional purpose. Just be sure not to leave any pattern paper within your piece as this will come away easily.

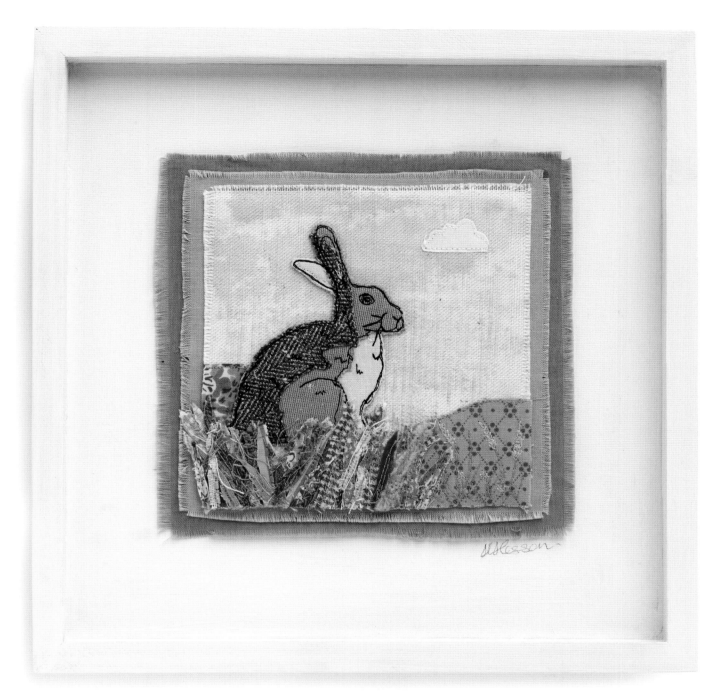

Wild Hare

This piece is mounted in a shallow box frame with no glass. Mounting a piece without glass allows more interaction with a piece and is particularly effective when you have incorporated some texture within the artwork.

Index

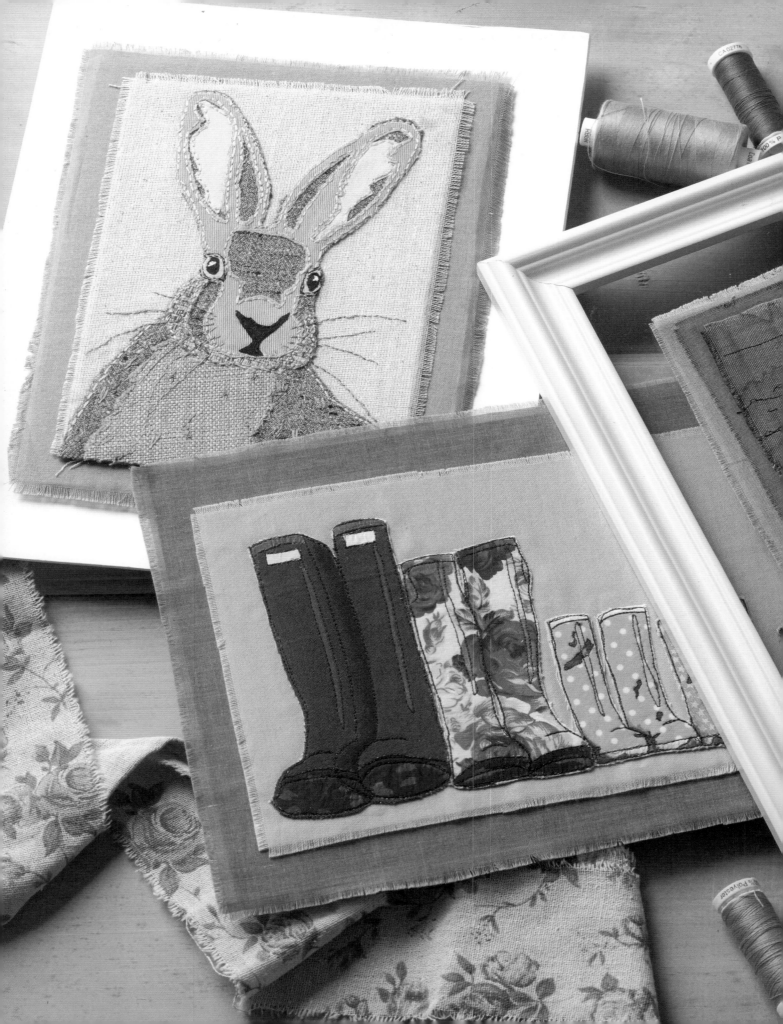

More from
THE TEXTILE ARTIST series

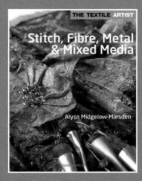

Stitch, Fibre, Metal & Mixed Media
978-1-84448-762-2

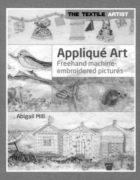

Appliqué Art
978-1-84448-868-1

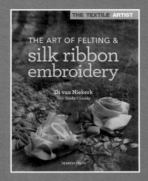

The Art of Felting & Silk Ribbon Embroidery
978-1-78221-442-7

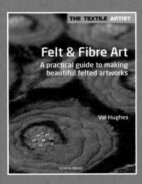

Felt & Fibre Art
978-1-84448-992-3

Layer, Paint and Stitch
978-1-78221-074-0

From Art to Stitch
978-1-78221-030-6

Layered Cloth
978-1-78221-334-5

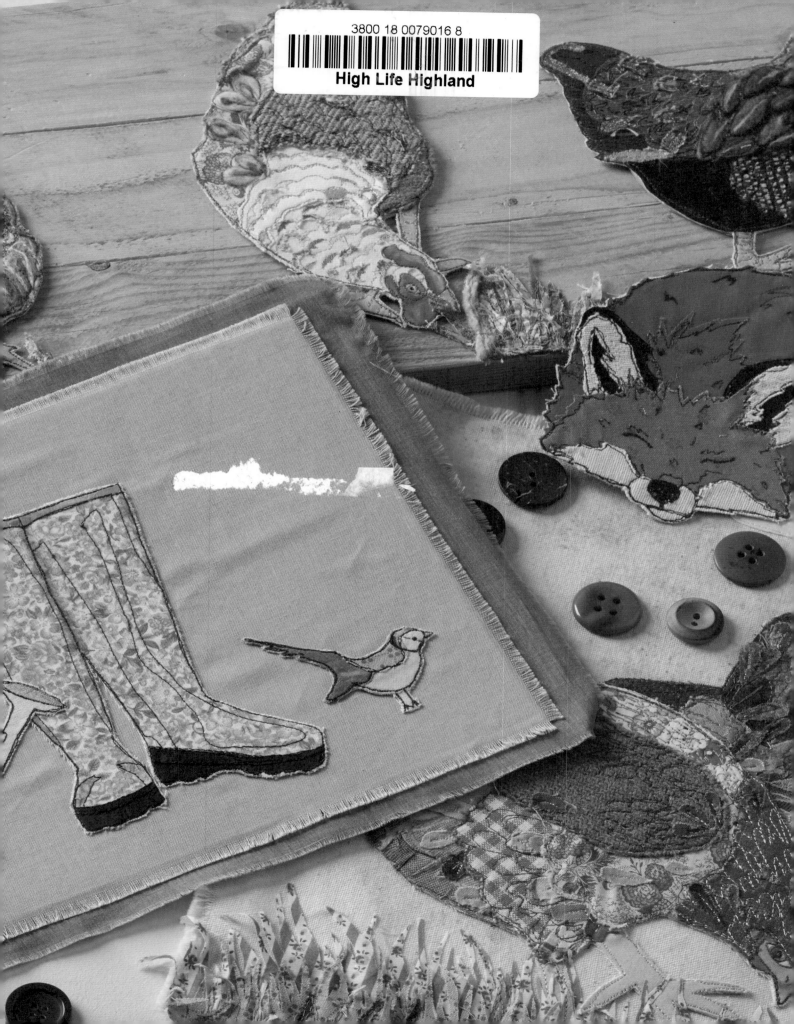